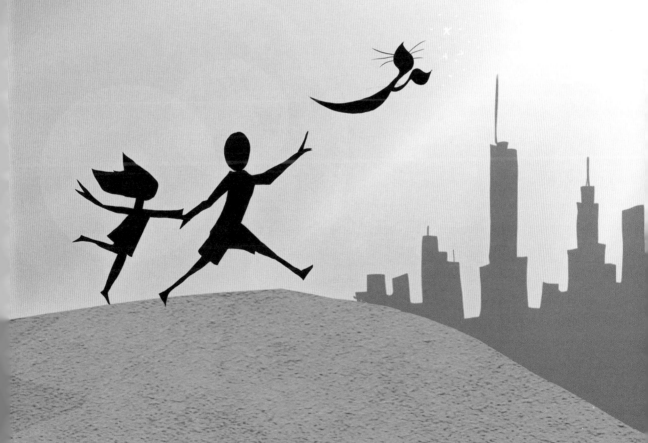

MALKAH'S NOTEBOOK

MALKAH'S NOTEBOOK

A JOURNEY INTO THE MYSTICAL ALEPH-BET

MIRA Z AMIRAS

ILLUSTRATED BY

JOSH BAUM

ISBN: 978-1-951412-34-0

LCCN: 2021902199

Manufactured in China.

Illustrations and design elements by Josh Baum.

Design by David Miles.

10 9 8 7 6 5 4 3 2 1

The Collective Book Studio

Oakland, California

www.thecollectivebook.studio

FOR MY FATHER
SEYMOUR FROMER Z"L

AND MY MOTHER
REBECCA CAMHI FROMER Z"L

Any place in which a righteous person
innovates words of Torah,
he comes to visit when he is in that world.
—*Zohar* [3:220a]

Would that I were righteous . . .

CONTENTS

PROLOGUE

Everyone has a creation story.
These are tales we tell ourselves
that make our origins distinct from others
and bring us closer to our people.

Our own stories, we call history or legend,
sacred or scientific truth.
Other people's creation stories, we call them myths.
We think they're quaint, blasphemous, a hoax,
or just plain wrong.

What if we believed
In-the-beginning . . ." was the beginning—
until one day we asked a different question,
and the sacred words sat up and
told a different story?

And the new story
opened a door to another, and another,
and more creation stories kept tumbling out.

What if we found a day *before* creation
inside the tale we call *Bireishit*, Genesis—
and what if it had been there all along,
sitting there in plain sight,
waiting for us,
ready to pounce?

What then? What do we do with that?

Come and see—

PART I

THE DAY
BEFORE
CREATION

ONCE THERE WAS AN ANCIENT CITY
on top of a high hill.

And there lived Malkah,
along with her wise old father
and his library filled with
dusty old books.

Malkah spent her days gazing
out over the city where
she had been born.

And her nights she spent
with her Aleph-Bet letters,
trying to make up words.

She had been drawn to the letters
from the very beginning.

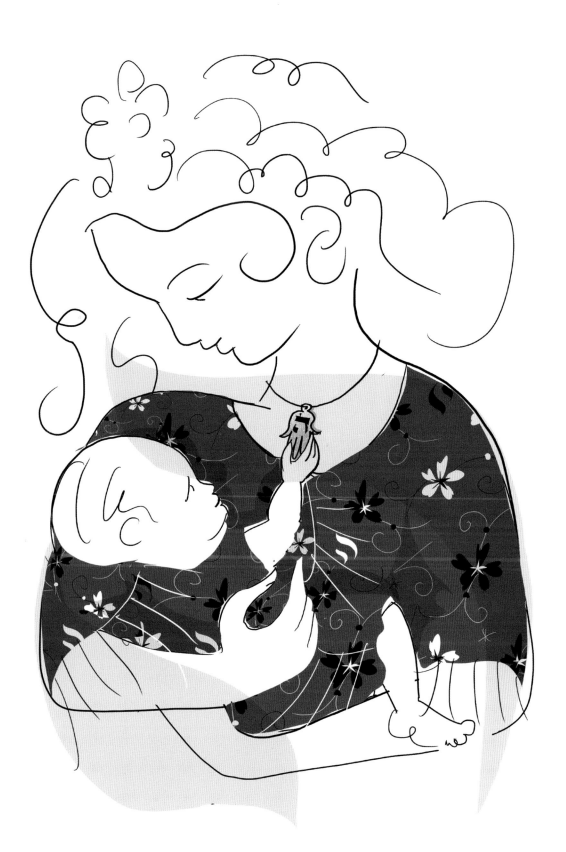

All the while,
both day and night,
her father spent with his
crumbling old books
in the dusty old library.

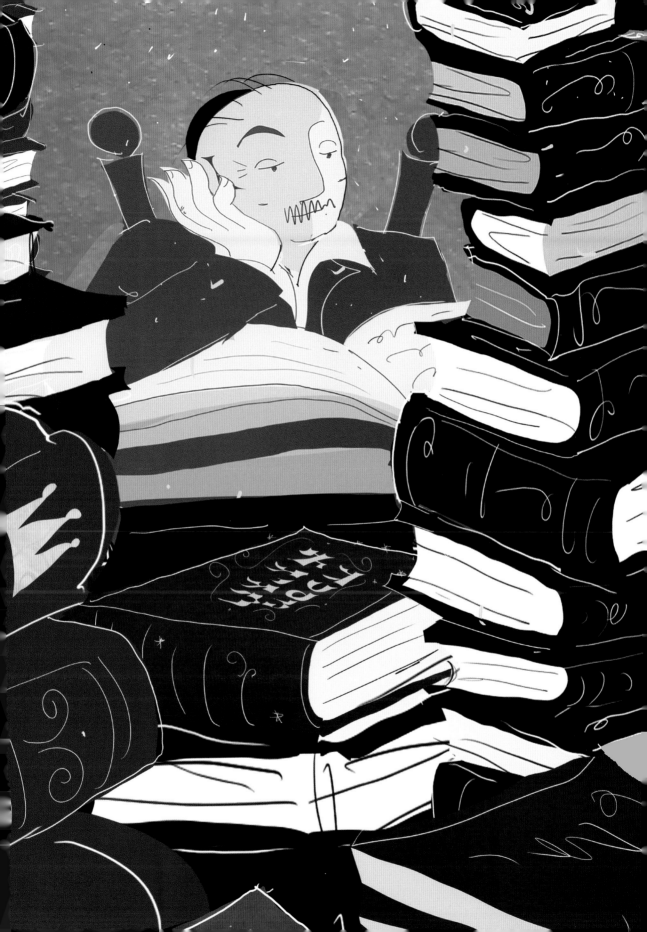

Once a year,
they would visit her mother,
who had died when Malkah
was still very little.

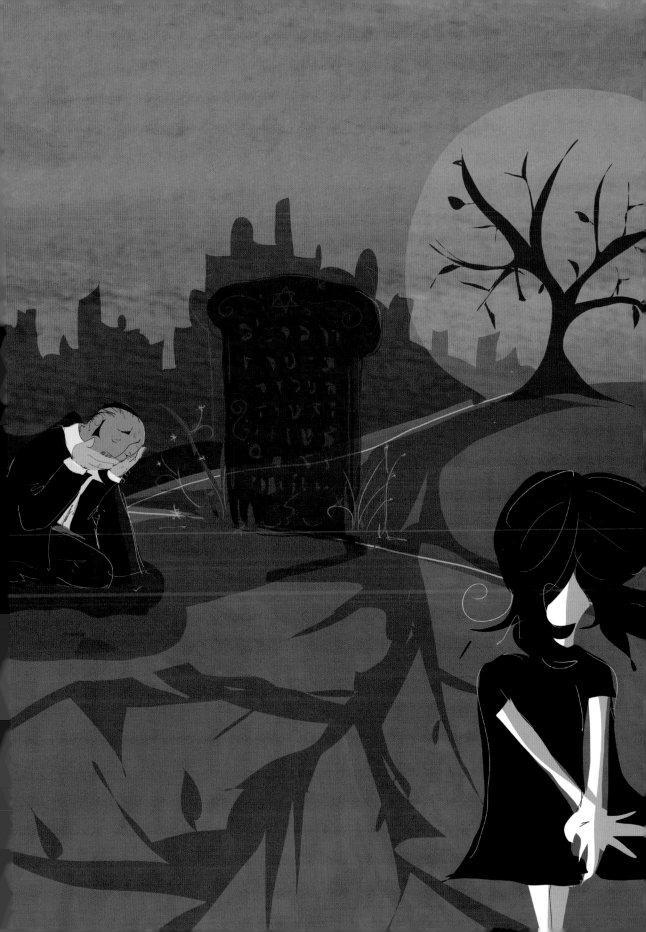

One night a visitor appeared

—as if out of nowhere—

and knocked over the

Aleph-Bet letters

that Malkah

had been playing with.

But two letters did not fall.

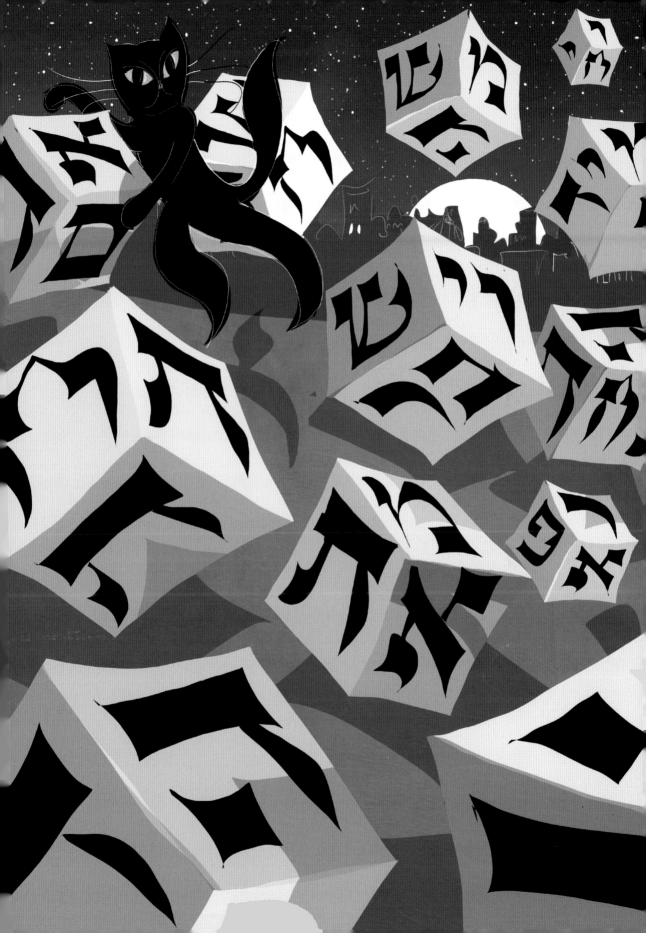

The א and the ת.

Malkah pondered the letters,
and tried to figure them out.

"את—*aht?*" she said.

"את—*et?*"
"את—*eet?*"
"את—*oht?*"

Without the little vowels staying in place,
the letters could say anything!

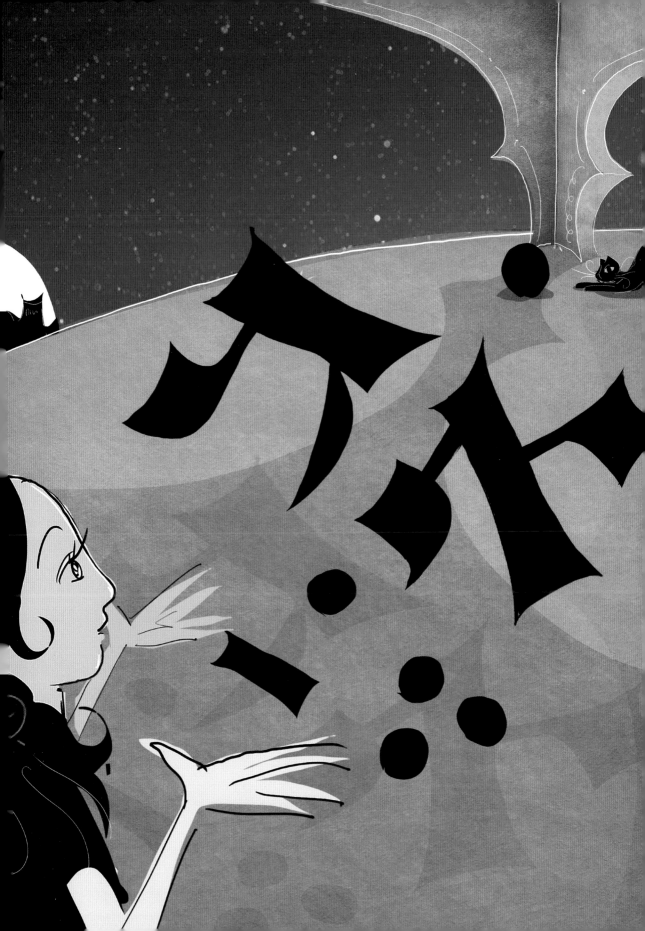

Finally
she called out
to her father for help.

"What does this say, Abba?"
she said.

And because of that
"simple" question,
Malkah's father decided
it was time to teach her.

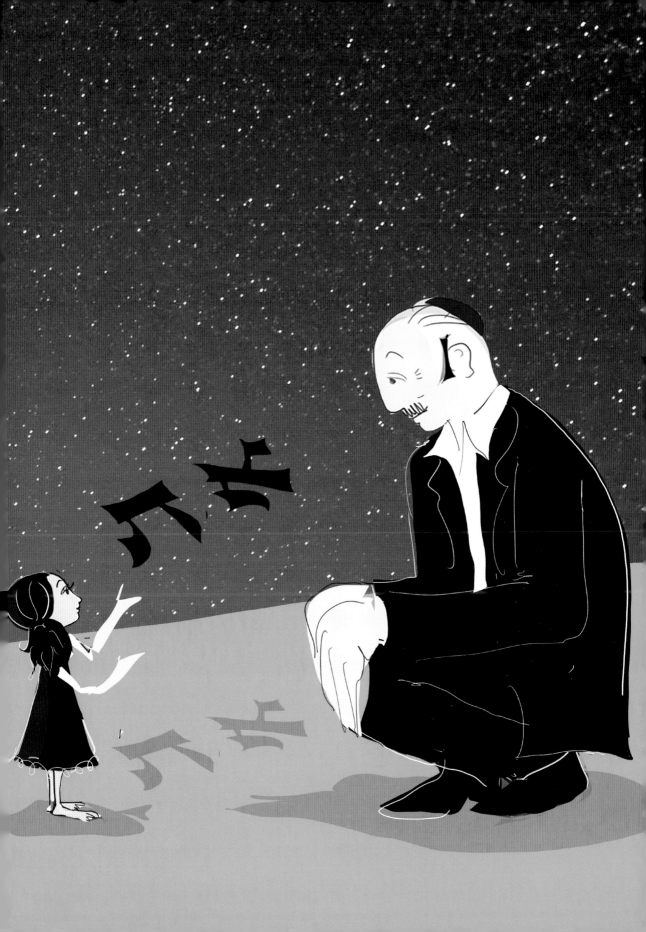

For the very first time
he invited her
into his library.
And Malkah looked around.

"Where do I begin?"
she asked.

"We begin,"
her father said,
"at the beginning."

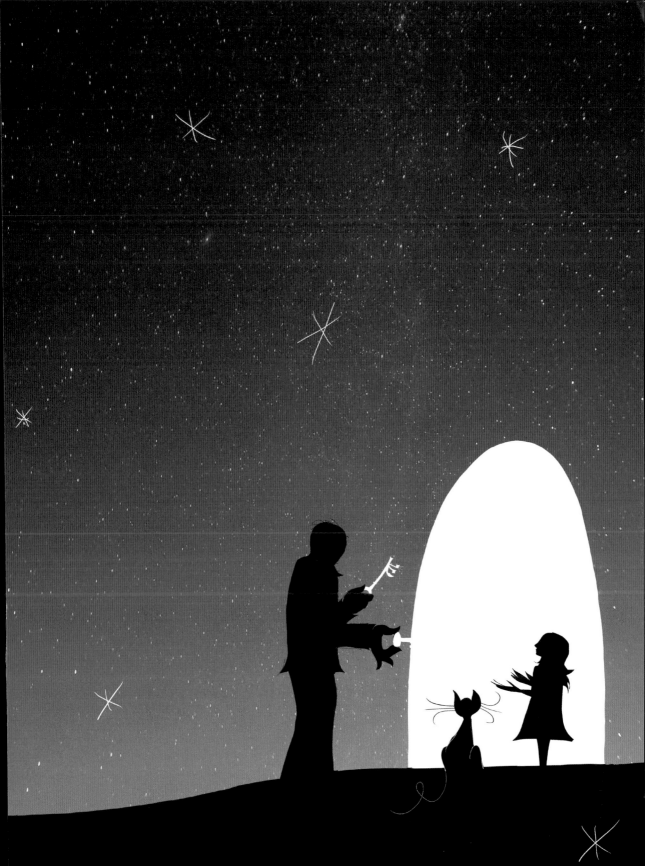

And he took
an ancient Torah
out of the ark.

This was it,
Malkah thought—

All the answers, all the wisdom,
all that made her father wise.

"Read!" he said,
and so, she read.

בראשית ברא אלהים את . . .

Bireishit bara Elohim et . . .

"In the beginning
God created . . .
the heavens
and the earth?"
she said, unsure.

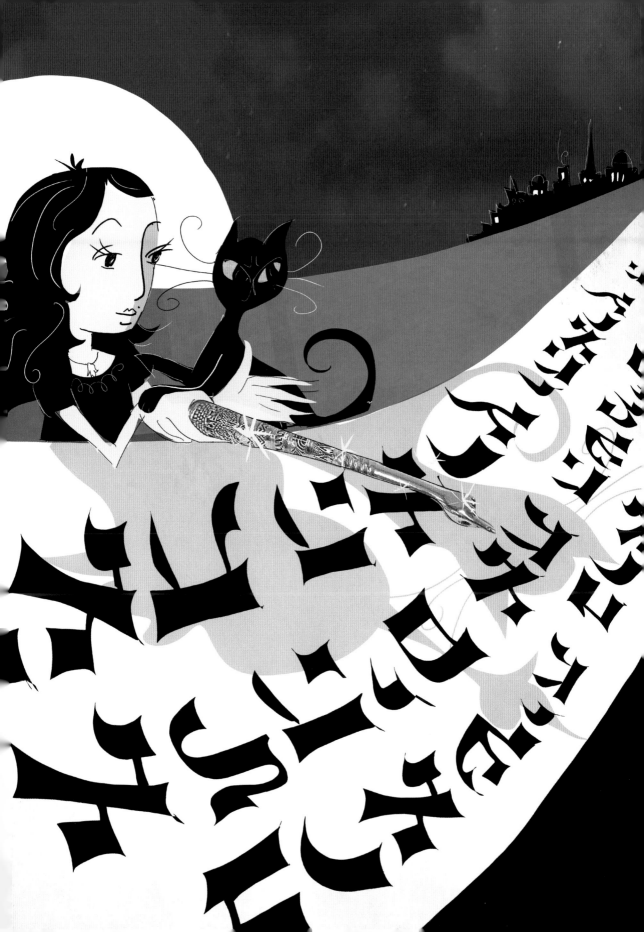

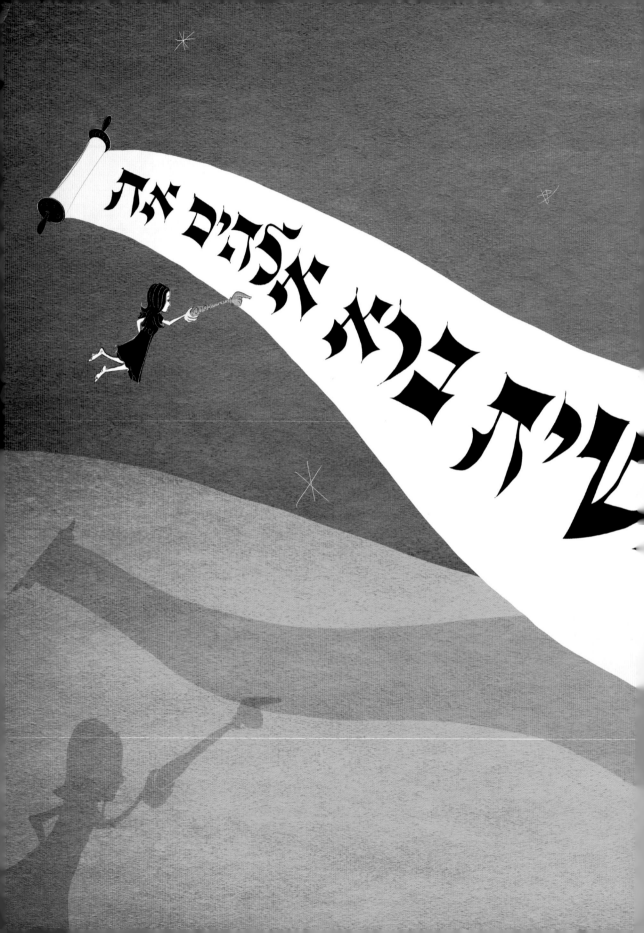

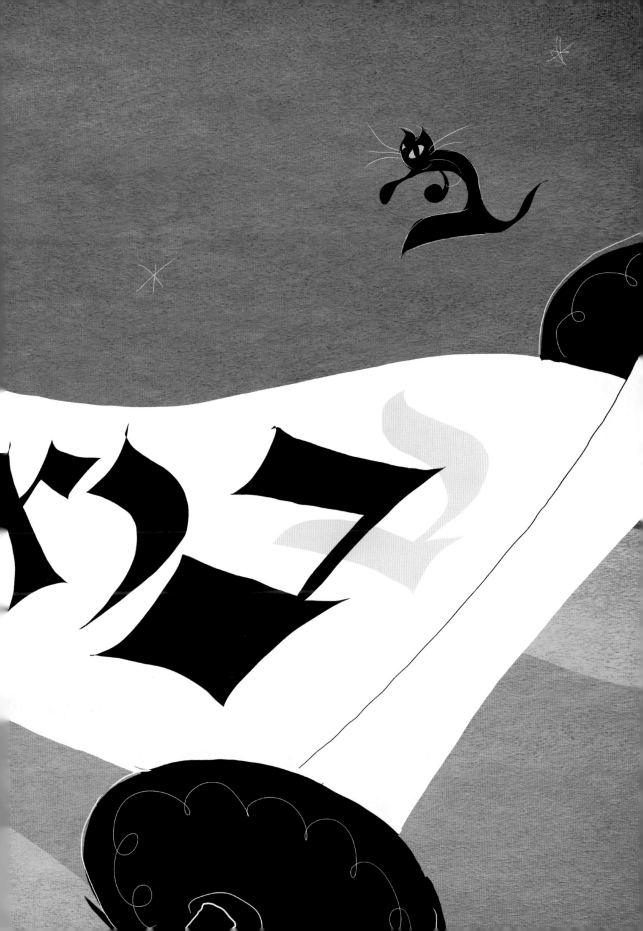

One sentence she read
and already something was wrong.

Those two letters
were still giving her trouble,

א and ת
.את

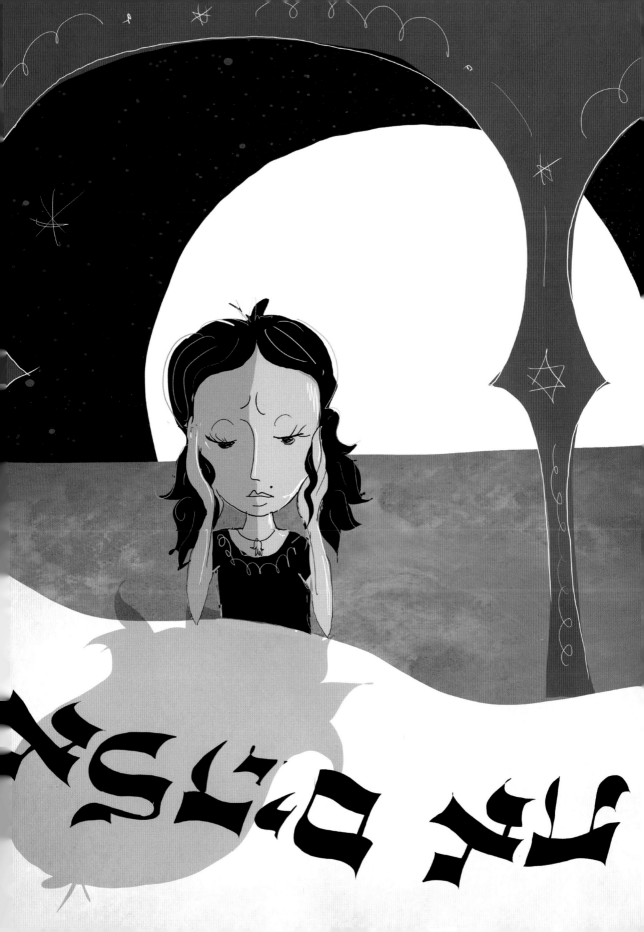

"Is there a problem, Malkah?"
her father asked.

Malkah's father loved problems.

Problems led to questions.

And questions, he always said,
opened doors.

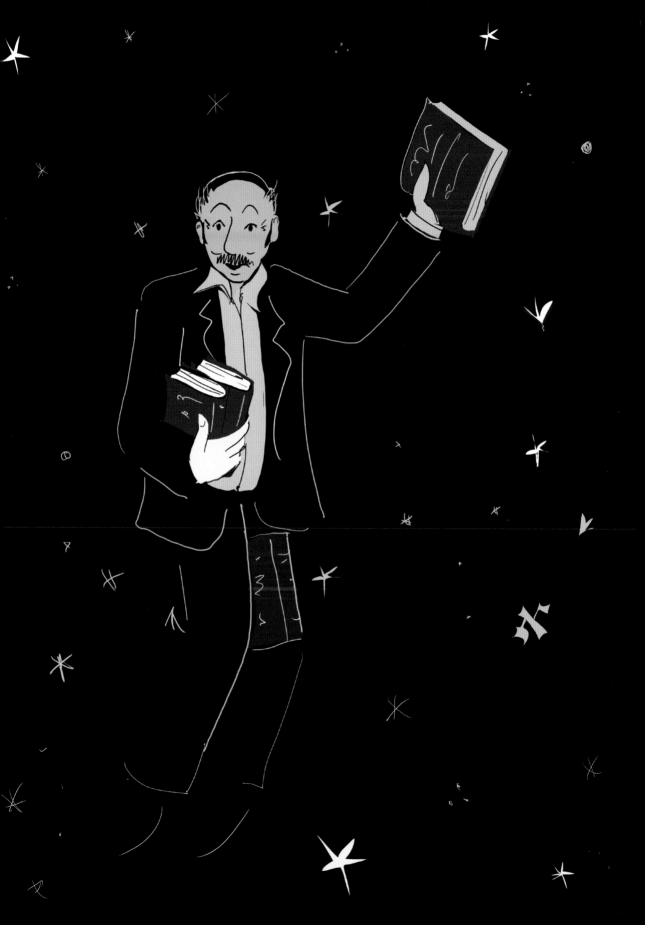

She wasn't too sure about that,
but still, she wanted answers.

"What are these את's doing here,
Abba?" Malkah asked.
"They don't seem to mean anything."

Malkah's father handed her
one bible after another in
many different languages.

And in every single one—it was true—
there was no word for את.

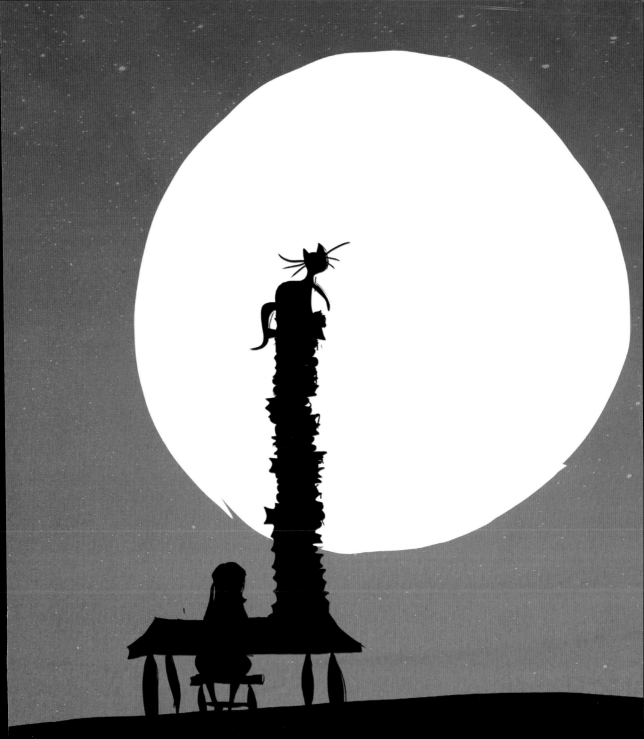

"Maybe," he said,
"maybe in Hebrew,
the language of the Torah,
we just put את in front of
everything God created,
and that's it, eh?"

Malkah didn't like that answer.

Why, she wondered,
would God put a word
that didn't mean anything
right at the beginning
of all creation?

"Good," her father said,
"so you tell me—

"What is את?"

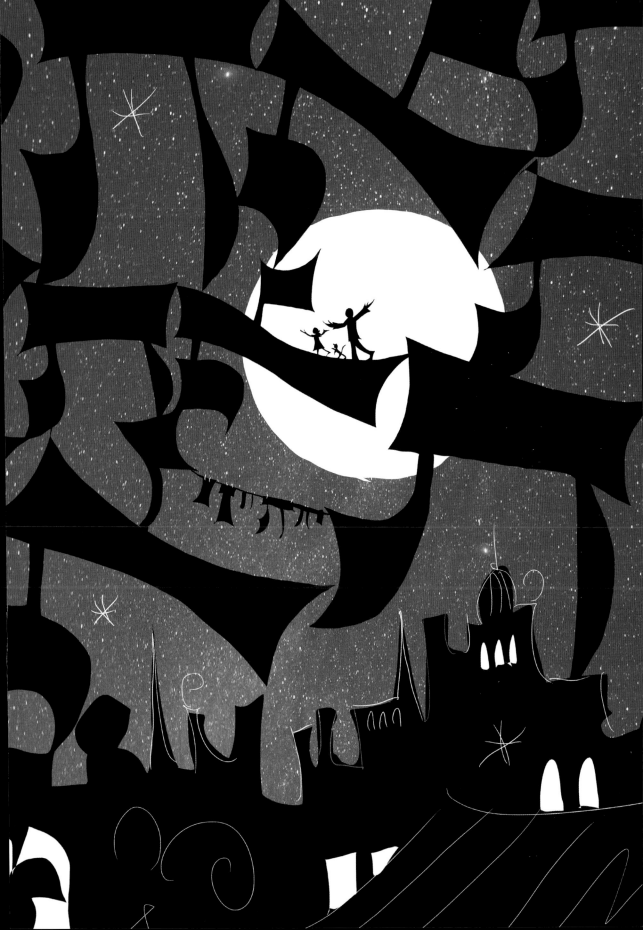

Malkah read the passage again
and again, and tried to figure it out.

Bireishit bara Elohim et—

She stopped right there.

In the beginning, God created את!

She was sure this was right.
But if God created את
before anything else,
it must be important
and it had to mean
something.

Malkah had found
her first puzzle in the Torah.

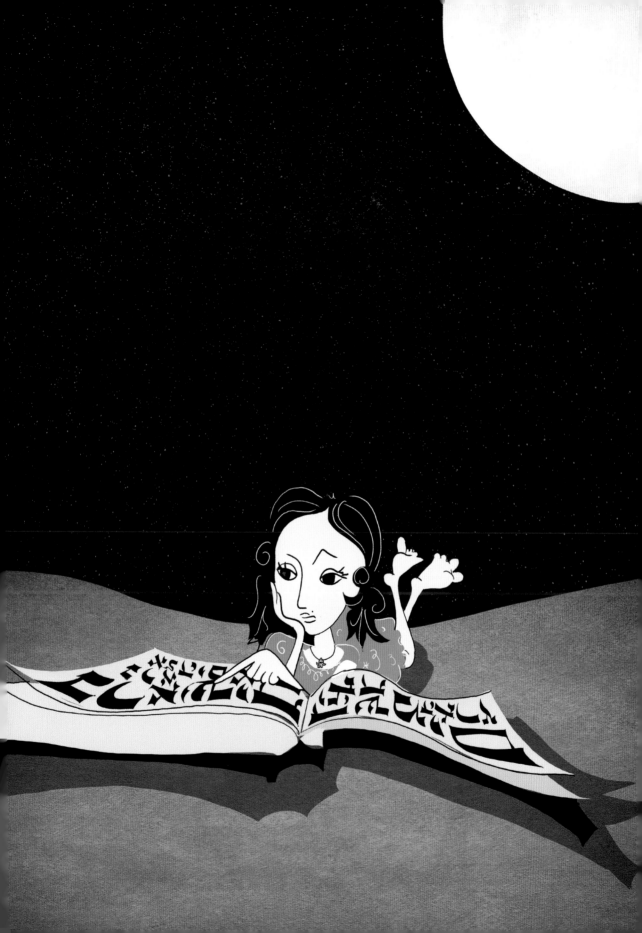

א is the first letter,
and ת is the last.
So—

In the beginning,
before the heavens
and *before* the earth,
God.
Created.
The Aleph-Bet.

And that's how
Malkah discovered
her first secret
in the Torah.

Malkah set out
to find more hidden things
inside the Aleph-Bet letters.

But when she looked
at the Torah again,
all she saw
was another problem.

"Tell me, Abba," she said,
"why does the Torah start
with the letter ב,
the second letter,
instead of א, the first?"

Abba didn't answer.

So Malkah pondered the ב alone.

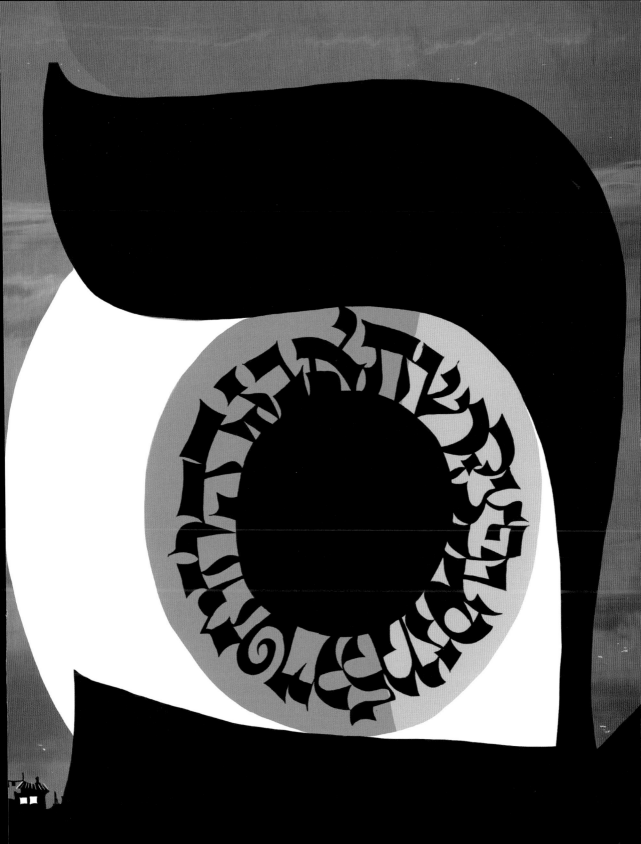

ב she knew was for *Bireishit*,
and for *bayit*—house.

But suddenly
she could see inside that house.

And there, deep down,
was a courtyard,
with a fountain
right in the center.

And the gateway
to the courtyard
stood open.

Malkah
was being invited inside.

Questions open doors,
Malkah thought.

And so she walked right in.

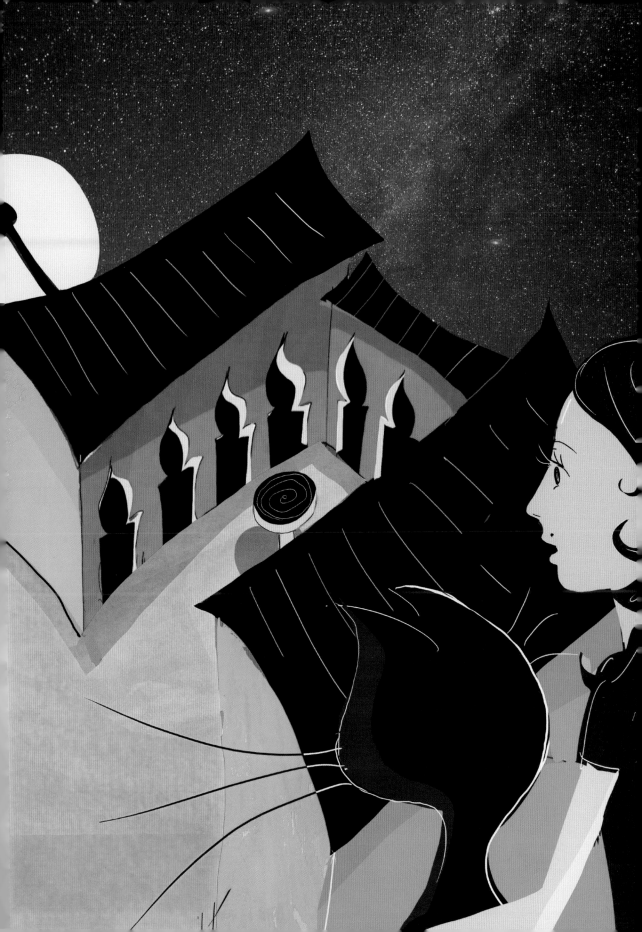

Inside the בּ
Malkah found herself
at the center of creation,
where all letters were born,
all words were made,
and all stories began.

She discovered
that all peoples have
creation stories of their own.

Some began with darkness.

Some with chaos.

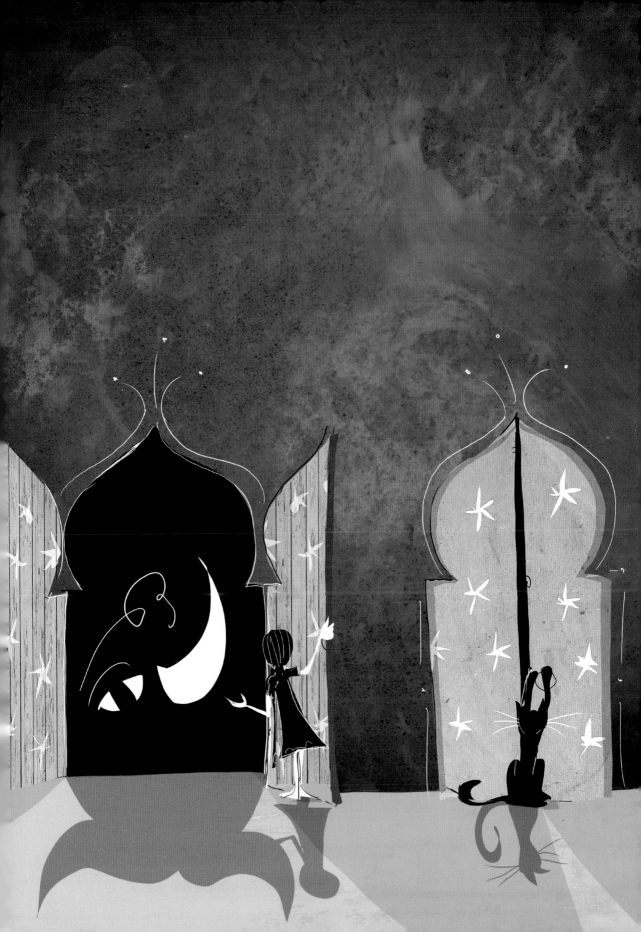

And some with nothing at all.

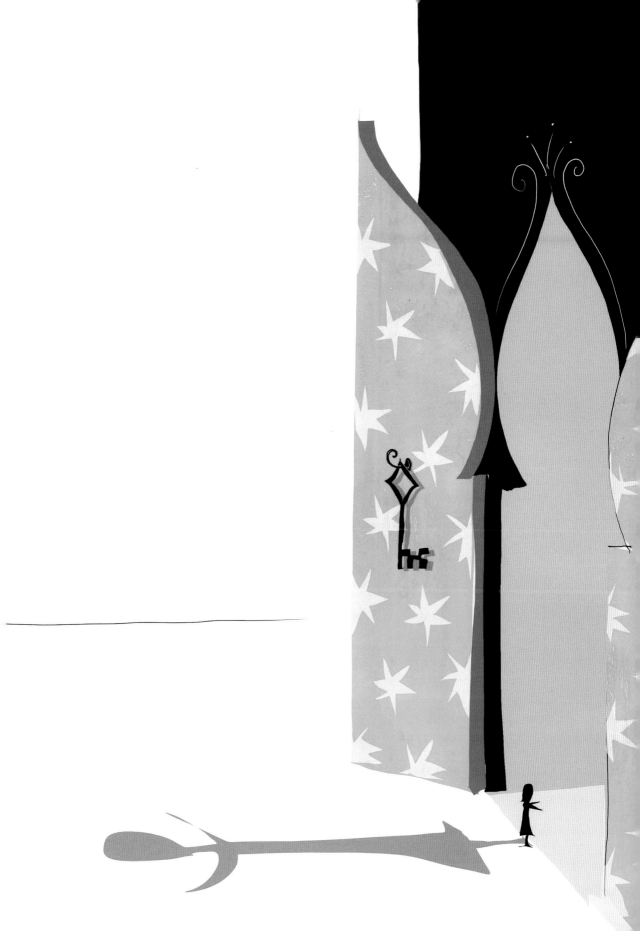

But the creation story
Malkah's father liked to tell
began with light.

Infinite Light.

Before the את,
before the ב,
before any letters at all—

The day *before* creation
there was only light,
with no darkness
anywhere to be seen.

"We call this light
Ohr Ein Sof,"
Malkah's father said.
"Light without end."

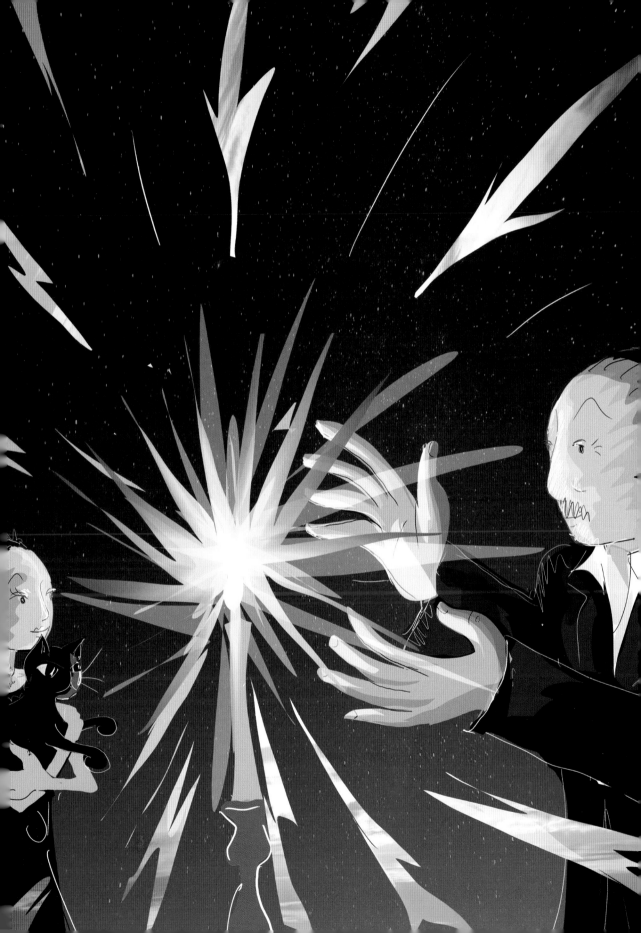

From deep inside the *Ohr Ein Sof*,
a contraction took place
—*Tzimtzum*—
and a dark space appeared inside
the primordial light.

"Contractions, Abba," Malkah said.
"Creation must be too big
for only one."

"Yes," her father said,
"and they formed a womb
for all, all of creation."

In this womb,
vessels emerged,
and a powerful thread of light
pierced every single one.

But the vessels were fragile.

They trembled,
and they shattered.

Sparks of the Infinite Light
became trapped inside
the broken vessels,
and scattered across
the newly created
universe.

They became no more than
bright but tiny points of light—
distant, hidden,
and unknown.

Malkah didn't like this creation.

Everything in it was
broken and
scattered.

It was not a world
she wanted to live in.

"Our sages teach," her father said,
"that this is our world.

"Here, there are many broken things,
broken dreams, and even
broken hearts.

"The story of shattering is a
reminder that the world,
it does need fixing.

"And it is our job, Malkah,
to repair the broken pieces."

"But you haven't
repaired anything,"
Malkah said.

"You just sit in your
dusty old library
and read your
crumbling old books."

Her father said nothing.

He just turned another page.

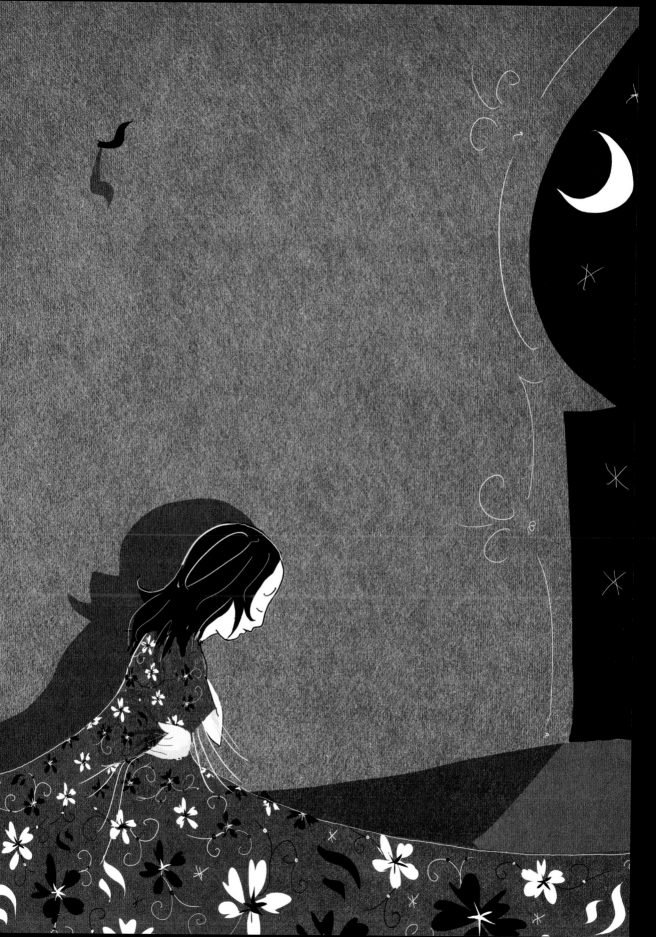

"Some things can never be fixed,"
Malkah said.

And she did not speak
to her father again that day.

Or the next.

Or the day after.

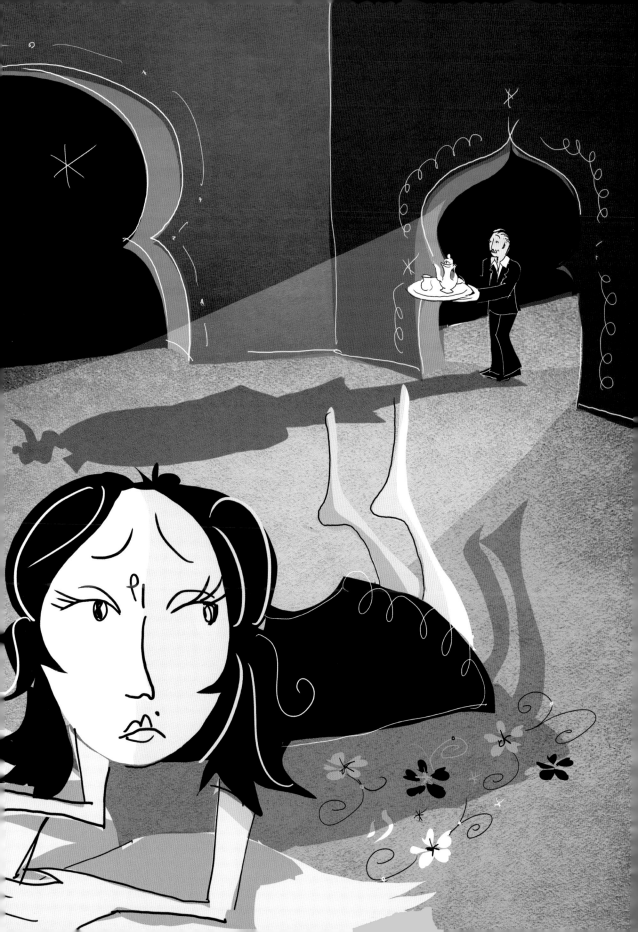

But one night,
her father's old books
were calling to her.

And Malkah found herself
drawn back to the library.

She discovered
there was more
to the story of *Tzimtzum*.

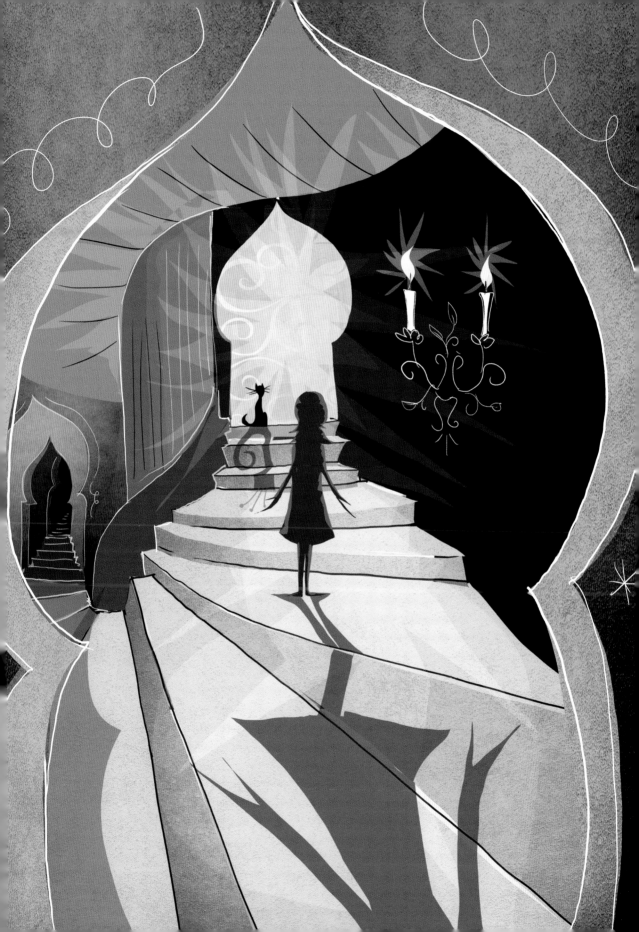

A second thread of light
emerged out of the *Ohr Ein Sof.*

There was a second try
—a second chance.

This time,
the light entered gently
inside the darkness.

And the vessels,
they did not shatter.
They became letters
of the Aleph-Bet.

First to appear
were the Mother letters.
First שׁ—fire
Then מ—water
Last, א rose above as air.

Next came
the Double letters,
each in two forms.

One empty:
like *vet* בּ.

And one full:
like *bet* בּ.

And last of all
came the Simple letters
—the Elementals—
each of whom had only one form.

And now the Aleph-Bet
was complete.

This was a very different
creation story.

"Every letter," Abba said,
"begins with a spark
of the Infinite Light.

"Here, you try it."

And he gave her
one of his old quills,
a new notebook, and
a bottle of ink just for her.

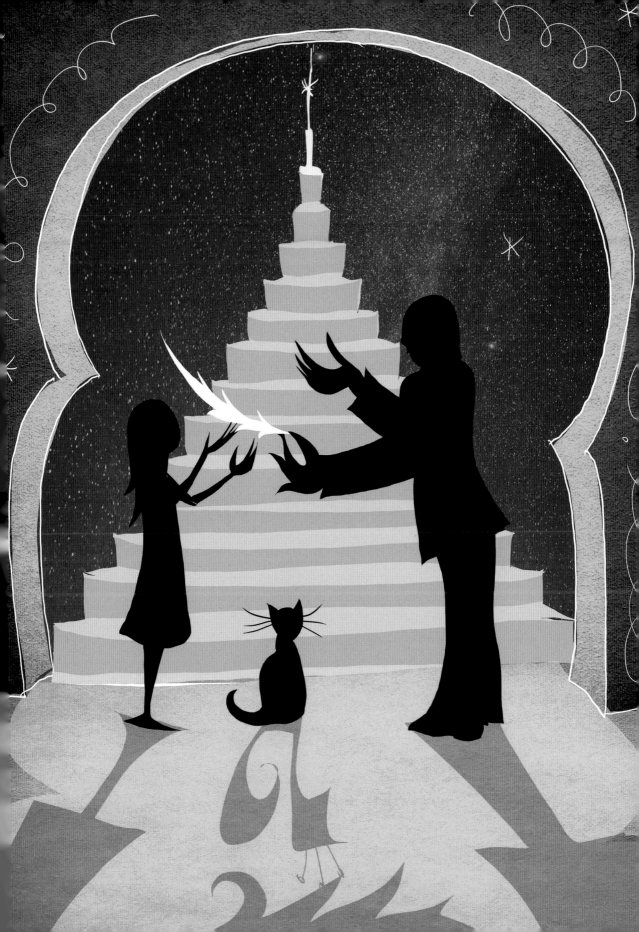

Malkah opened her notebook,
and she tried to make her letters.

She started with א,
but her lines began to grow.

Her hand followed along
behind the quill, until at last
she saw what together they had done.

It was a picture—
a picture of creation.

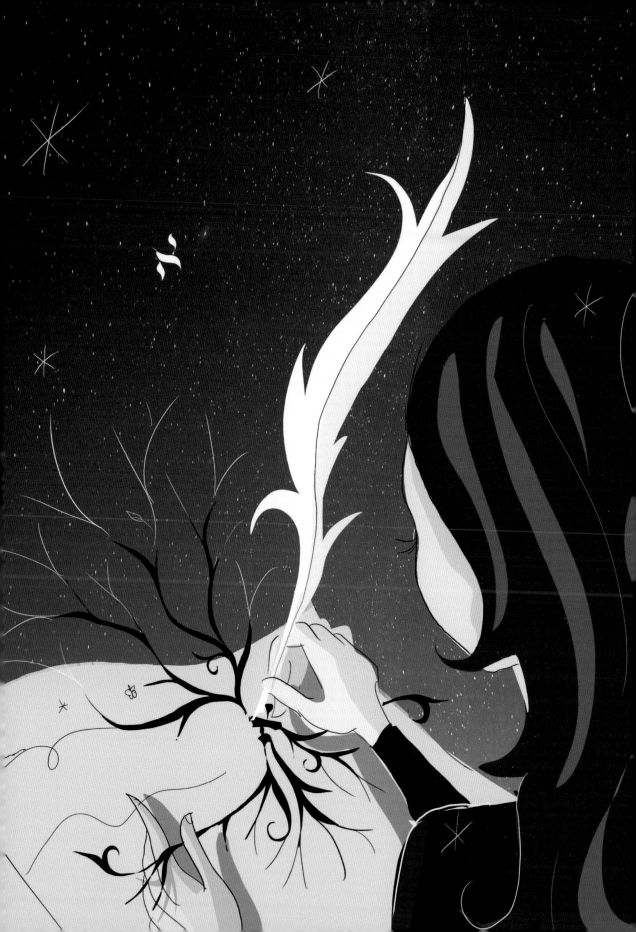

Malkah was confused.

Could anybody just make up
a creation story?

Was it as *Bireishit* tells us,
"In the beginning God created
the heavens and the earth?"

Or was it the Aleph-Bet letters
who were created first,
deep inside the mysterious את?

Did creation start inside the ב?

Or did it begin with Infinite Light
and vessels that shattered?

And what about all the other
creation stories in the world?

"I like best," she said to herself,
"the one with the Aleph-Bet letters."

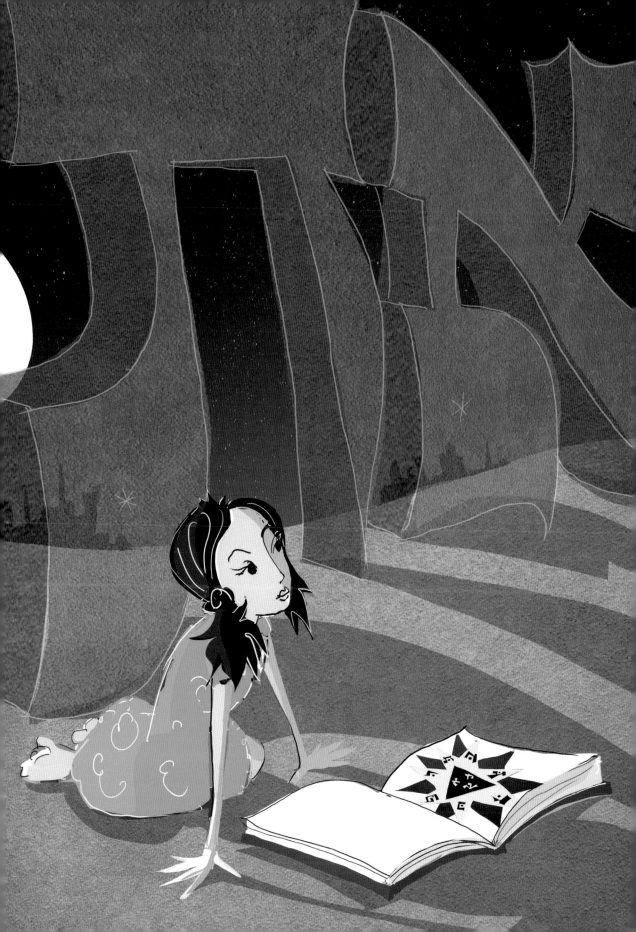

But Malkah was pretty sure
she could not just pick and choose.

If one creation story was right,
then all the others had to be wrong.

"I don't believe any of these stories,
Abba," she said.

"You can believe or not believe,
Malkah," he said.

"Either way is a good start."

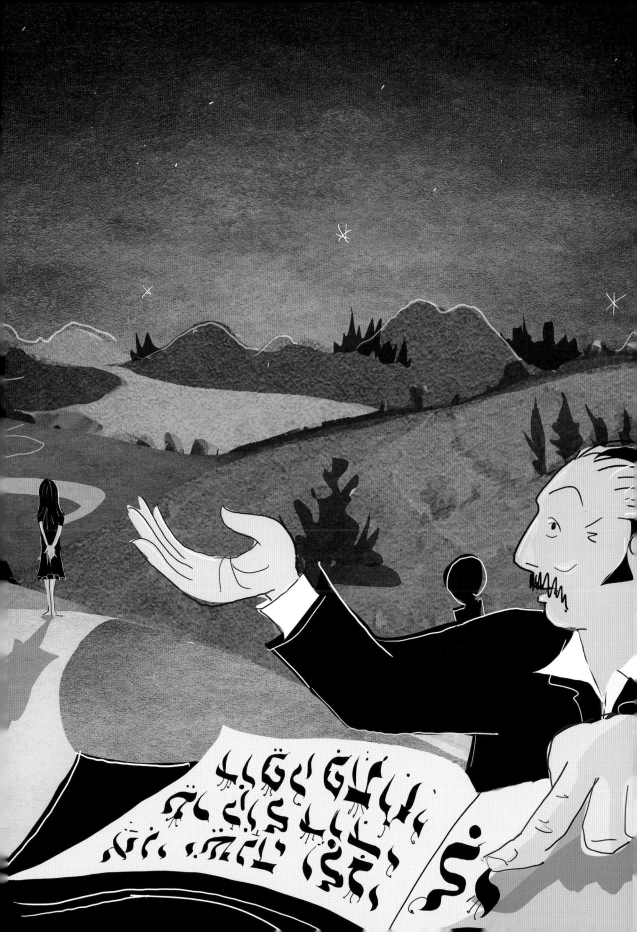

"Maybe," Malkah said,
"maybe questions are more important
than belief?"

"Our ancestors, they talked with God,"
her father said. "They wrestled.

"Either you have the conversation,
or you don't."

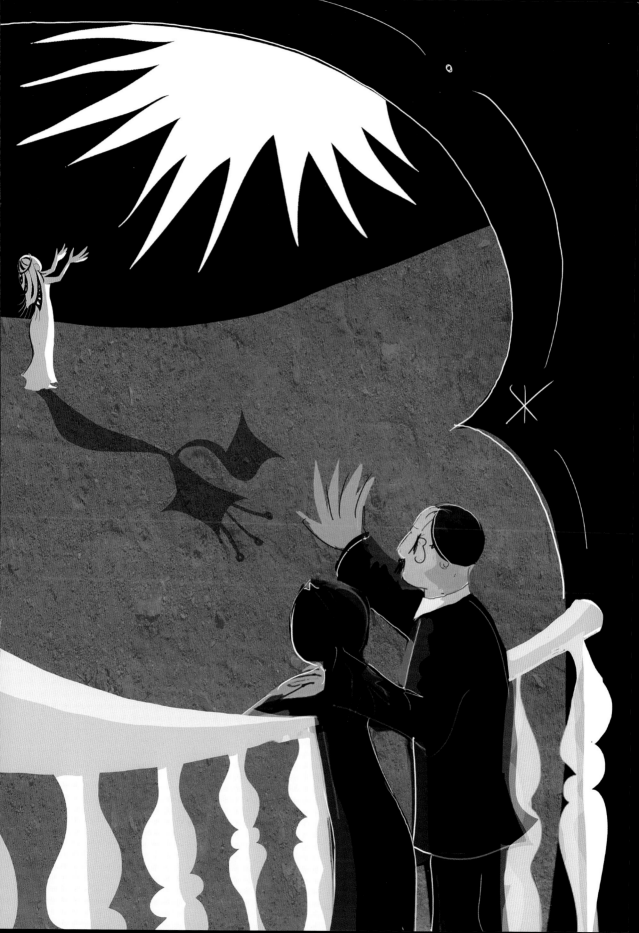

Malkah thought about
her grandfather,
the atheist.

He believed in the power
of workers joining hands,
but not in a God
who would help them
on the picket line,
fighting for their rights.

"Did Grandfather wrestle
with God?" she asked.

"He wrestled," her father said,
"he wrestled with
everything!"

Malkah fell asleep,
and she dreamed of her grandfather.

And he was wrestling with God.

"Questions are exactly like
your dreams, Malkah,"
her father said.

"You don't have to believe in dreams
to follow where they lead."

"And where do they lead?"
Malkah wanted to know.

"Each question," he said,
"is a shard of the Original Light.

"With such illumination,
we can see our mistakes.

"And in that way
we can repair the world."

"Letters make words," she said,
"and words tell stories, all stories. . . ."

Malkah decided that letters could make
just about anything happen.

"*Abra-c'dabra!*"
her father said.

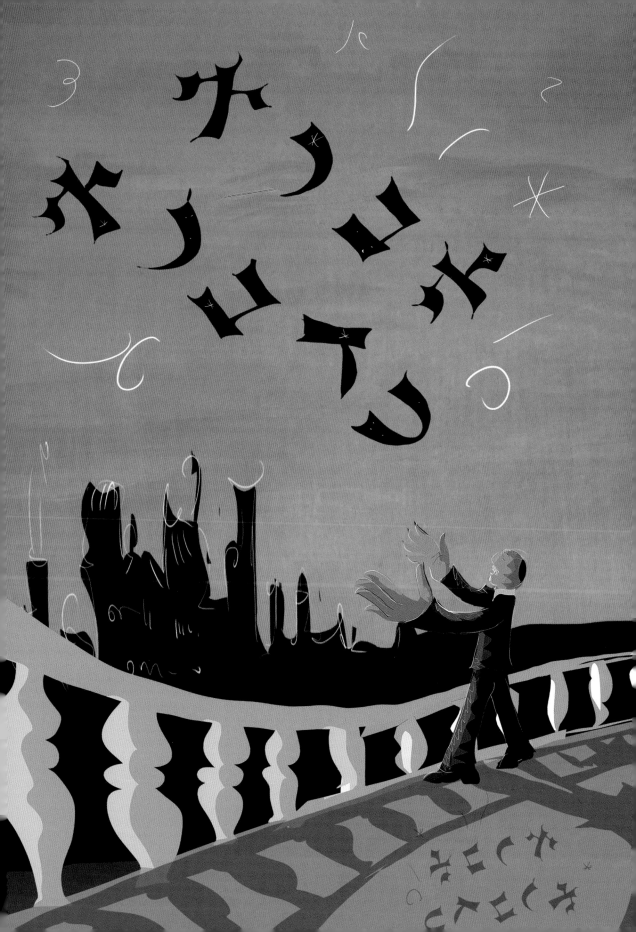

"*Abra*—I create
c'dabra—as I speak."

"*Abracadabra*?" Malkah said,
"that's how God created the world?"

She tried it.

And waited.

How would she know
if anything happened?

Would the world be
any different?

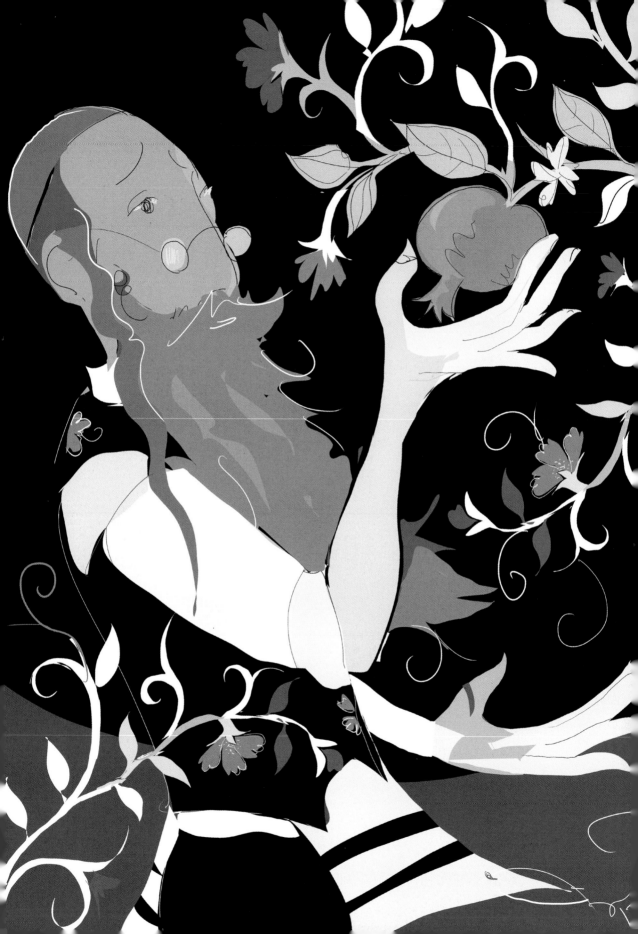

PART II

SAGES IN PARADISE

MALKAH'S *ABRACADABRA*
had awakened something
in her father's dusty old library.

"Abba," she said, surprised—
"tell me, tell me again the tale of
the four sages who entered Paradise."

Each time he told it, it was different,
and so each time she listened.

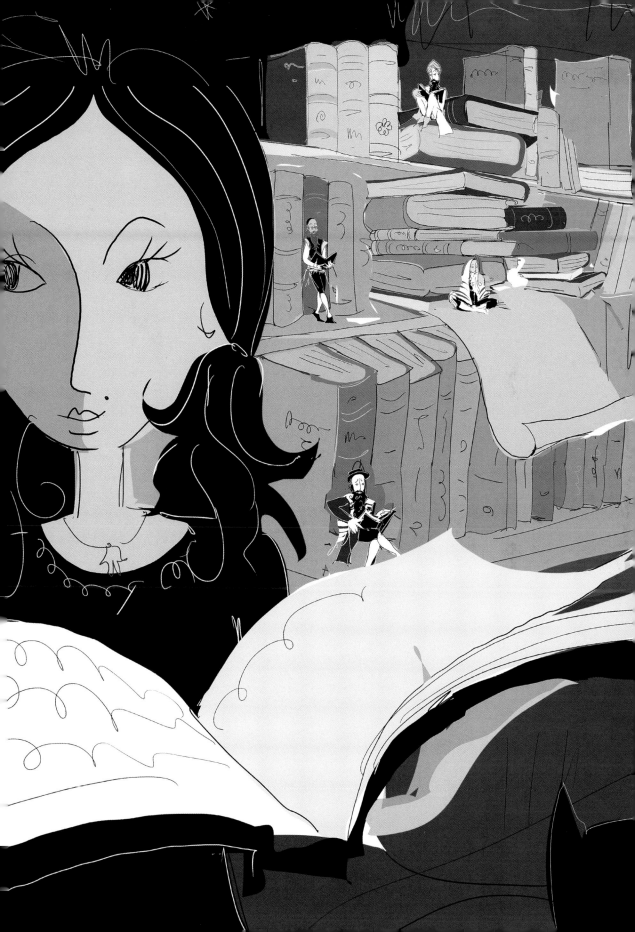

"So," he said,
clearing his throat,
"once there were Four Sages,
and they ascended into Paradise,
which we call *Pardes*.

"*Pardes*, in Hebrew, means orchard.

"But as you know, Malkah,
Pardes is no ordinary orchard."

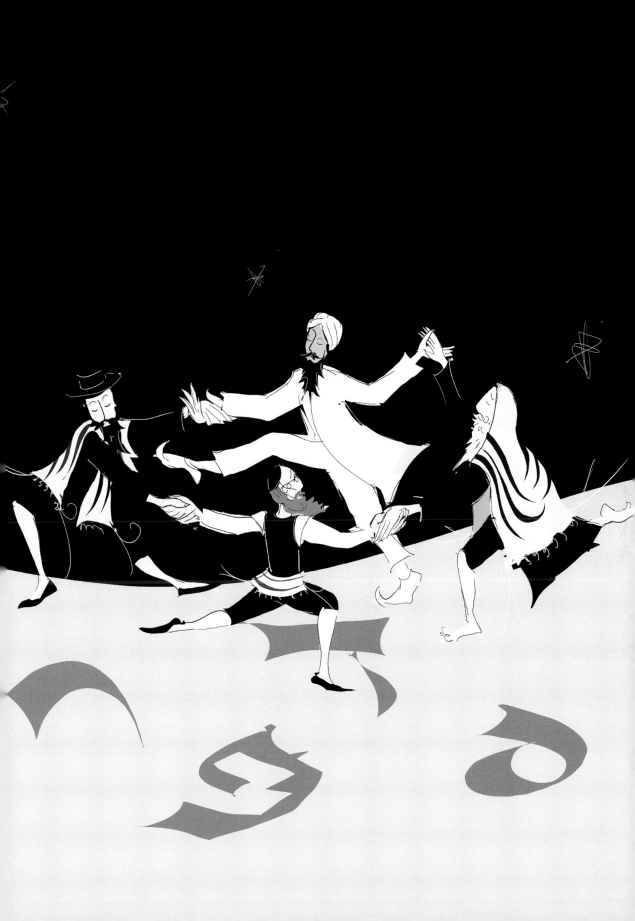

The only way in
is through the Hebrew letters
that spell out the word
Pardes itself.

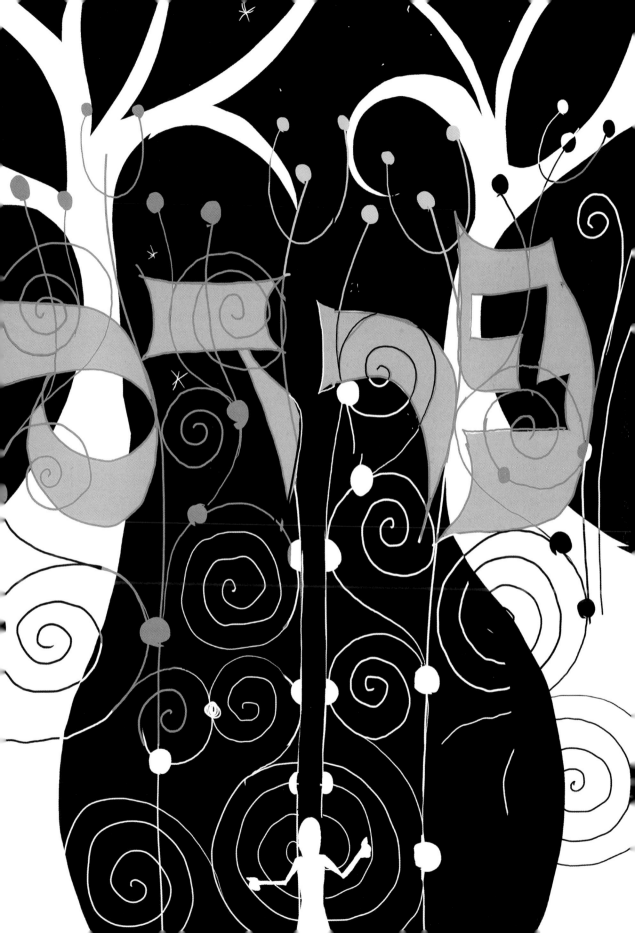

"So," Abba said again—

"So—the First Sage,
he entered *Pardes*
through the letter פ.

"Now this letter
holds a secret
that most people
do not see."

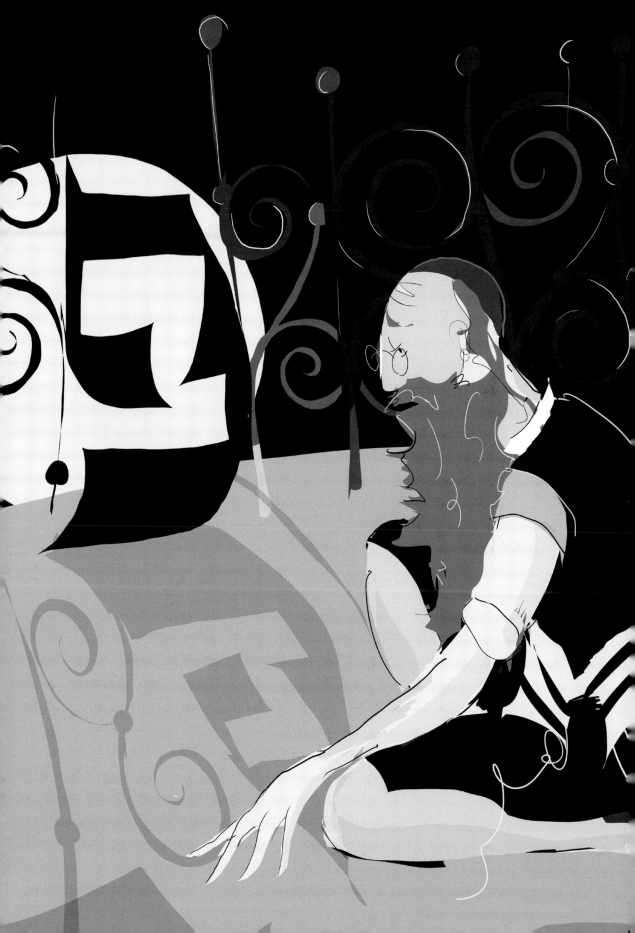

פ
it stands for
פשט
pshat, simple or superficial,
for those who cannot see
beyond the surface.

And the First Sage,
he was such as these.

And so, when he saw
the Garden of Paradise,
a simple garden
was all that he
could see.

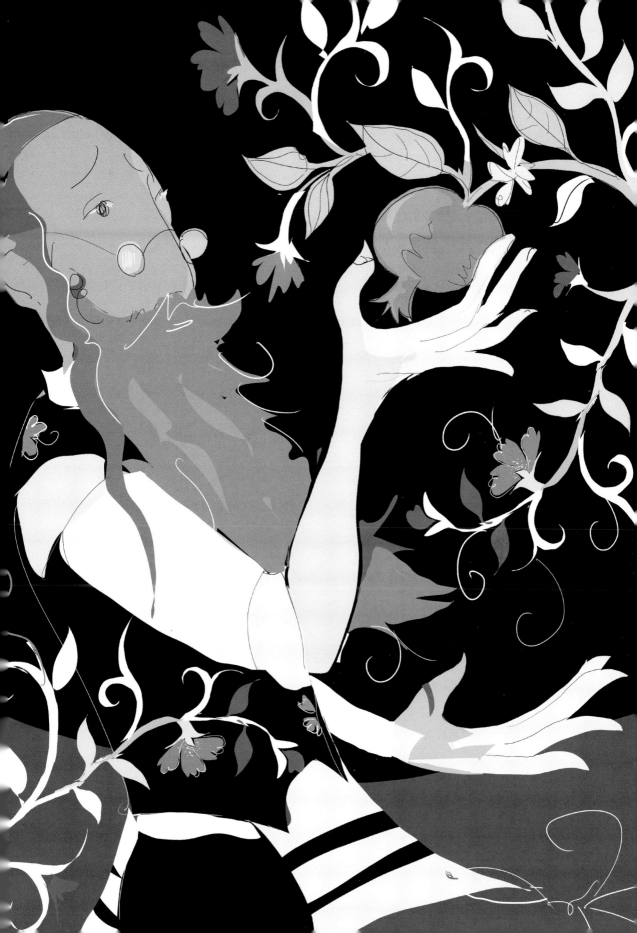

He took some cuttings
so he could plant
a garden of his own in this,
the physical world.

"Nothing wrong with that," Malkah said,
"a garden is a good thing!"

"But *Pardes* is more
than a garden,"
Abba said,
"just as Torah is more
than a book."

"But," said Malkah,
"what did the First Sage ask
about Torah?"

"He did *not* ask,"
Abba grumbled.

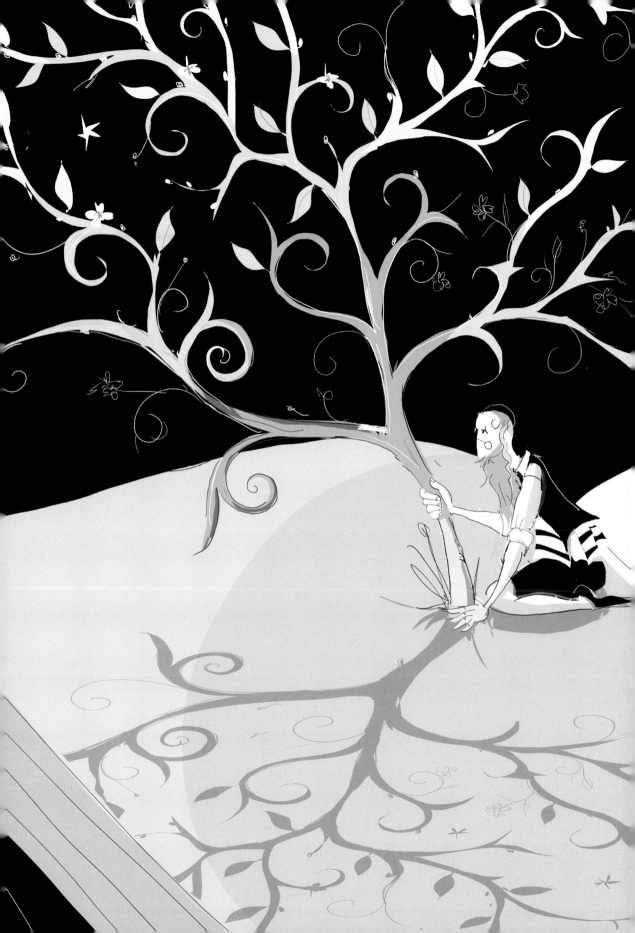

"If you read Torah
only like the First Sage,
you could never
find the letters
hidden inside the את.

"All you would see
is what is written in ink,
and probably not even that."

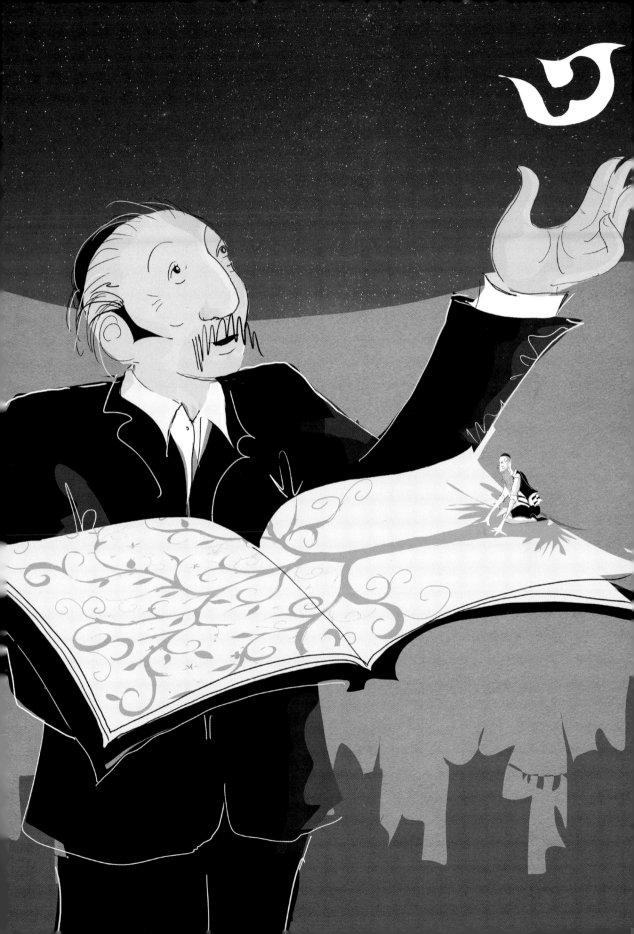

"But Abba,"
Malkah said,
"I like the First Sage.

"He's simple.
"He wants sunshine.
"He's left the library!"

Abba grumbled again,
and even started
to mutter.

"The Second Sage," said Abba,
"he entered *Pardes*
through the letter ר.

"Now ר is a
very difficult letter,
for there are many confusing things
that we carry in our heads."

"ר stands for רמז, *remez,*
which means hint or clue.

"And the Second Sage,
he looked everywhere
for clues—for *meaning.*"

Malkah had always liked
this sage.

The search for meaning
was something she
could understand.

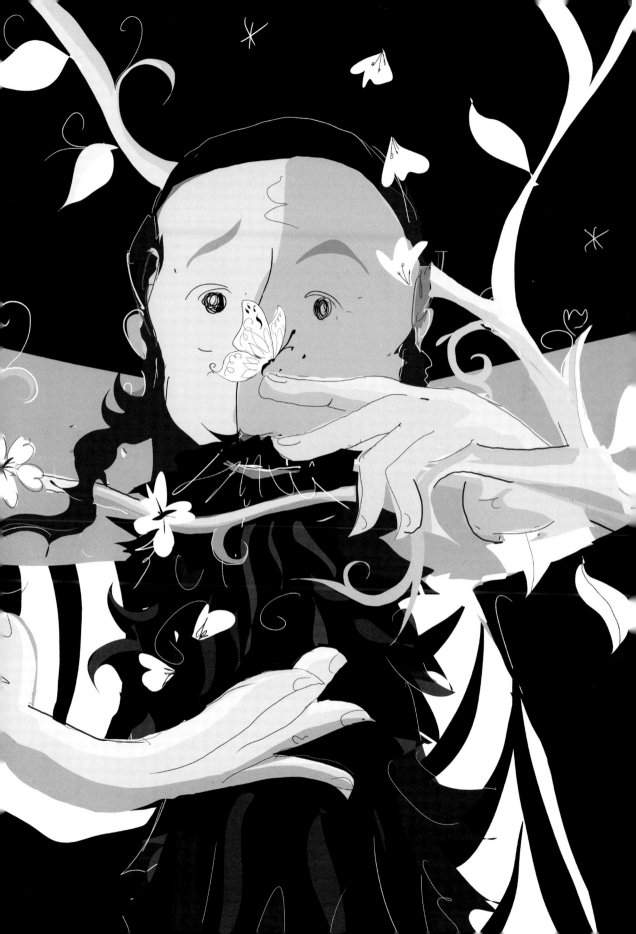

"But the Second Sage," Abba said,
"came up with too many meanings.

"He became perplexed.

"So much so that he lost his mind.

"For if everything is meaningful,
then nothing has meaning
anymore."

Abba paused for a while,
deep in thought.

"Go on," said Malkah.
"I like this story
no matter which way you tell it."

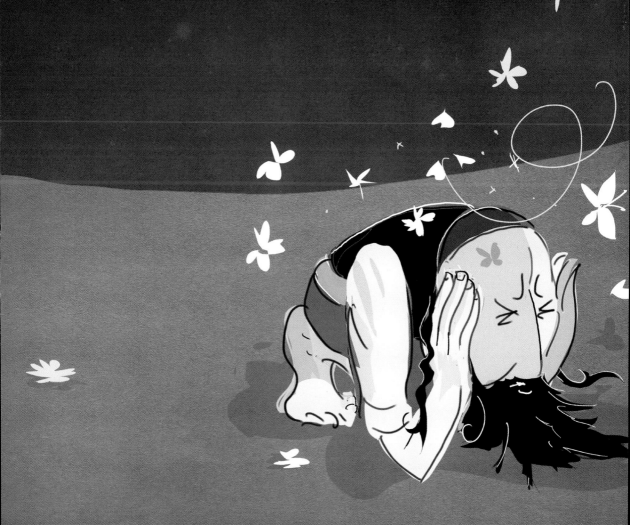

"So the Third Sage," said Abba,
"he entered *Pardes*
through the letter ד,
the letter that opens doors."

"ד is for דרש, *drash,*
for seeking.

"And the Third Sage,
he was a seeker."

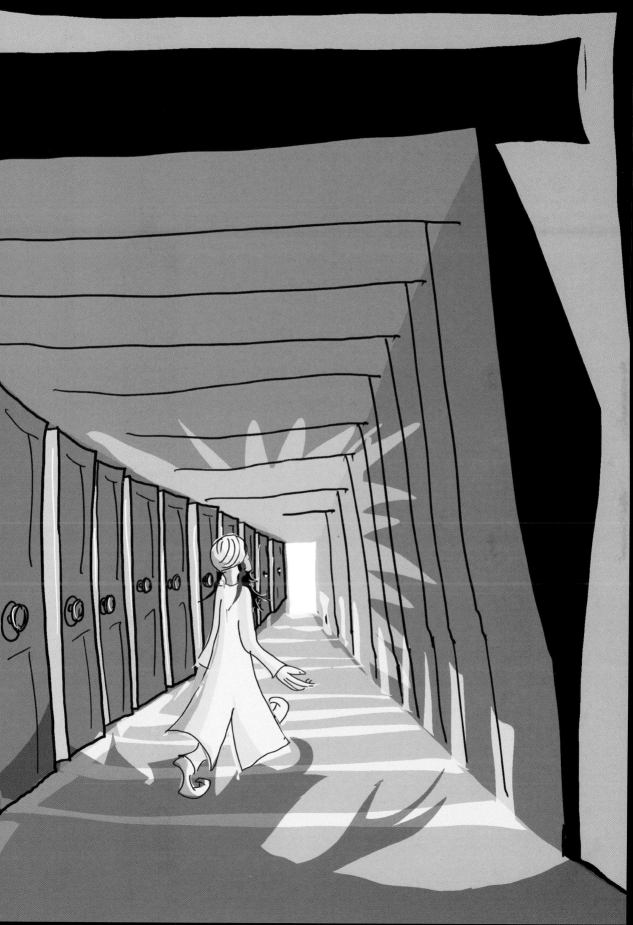

"He began to ascend,
but just like that—

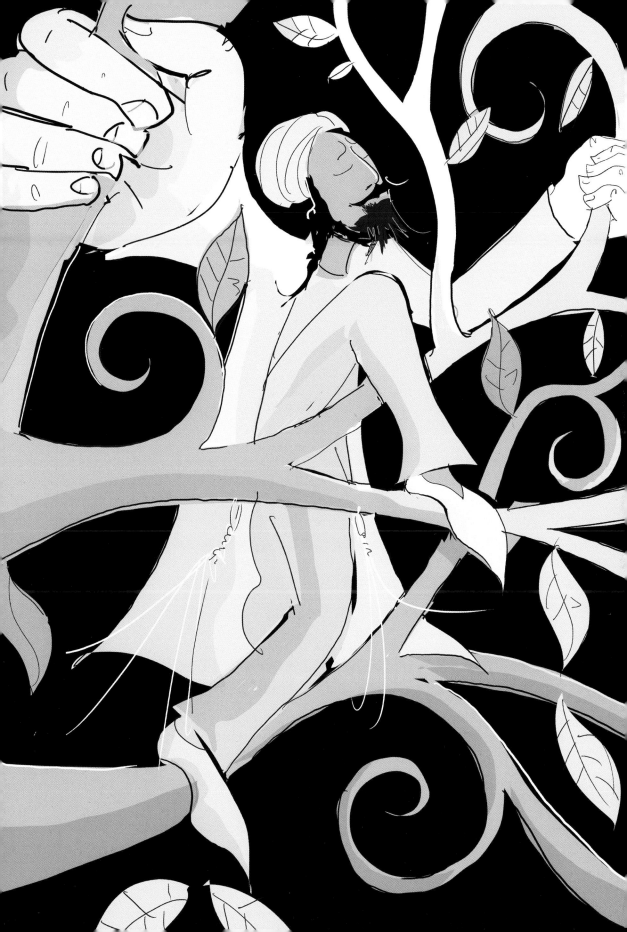

"—he was struck down
and he died."

Malkah wanted to know
exactly what the Third Sage
had done that was so very wrong.

She always asked Abba this question,
and he always answered the same way.

"Some say he was punished for doing evil,
and some say he was rewarded for doing good."

"That doesn't even make sense,"
Malkah muttered, as she always did.

"What we do matters, Malkah,"
Abba said, not for the first time.

But this time, Malkah wanted to know
how we could tell the difference
between good and evil,
when sometimes
it wasn't so clear.

"Aha!" her father said.
"Now that, *that* is a question!"

And he stopped
and thought for a long while.
But he did not answer.

"Go on, then," said Malkah.

He was getting to her favorite part.

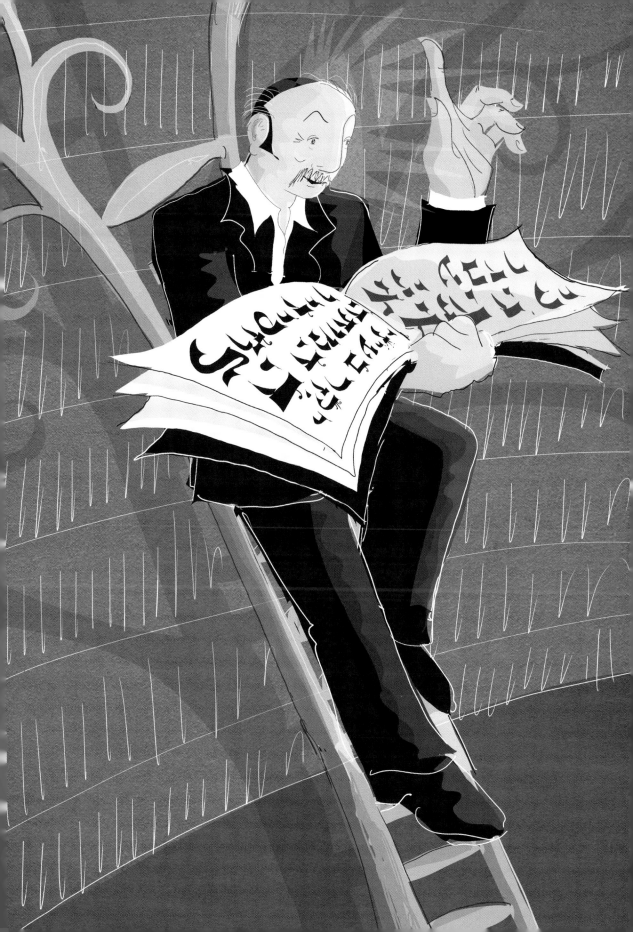

"Now, the Fourth Sage," said Abba,
"was Rabbi Akiva.

"As it is written,
He entered in peace,
and he left in peace."

"Rabbi Akiva came
through the letter ס,
which is whole
and complete.

"It stands for סוד,
Sod—the hidden place
where the mysteries
of the universe reside.

"All that was hidden,
to him it was revealed.

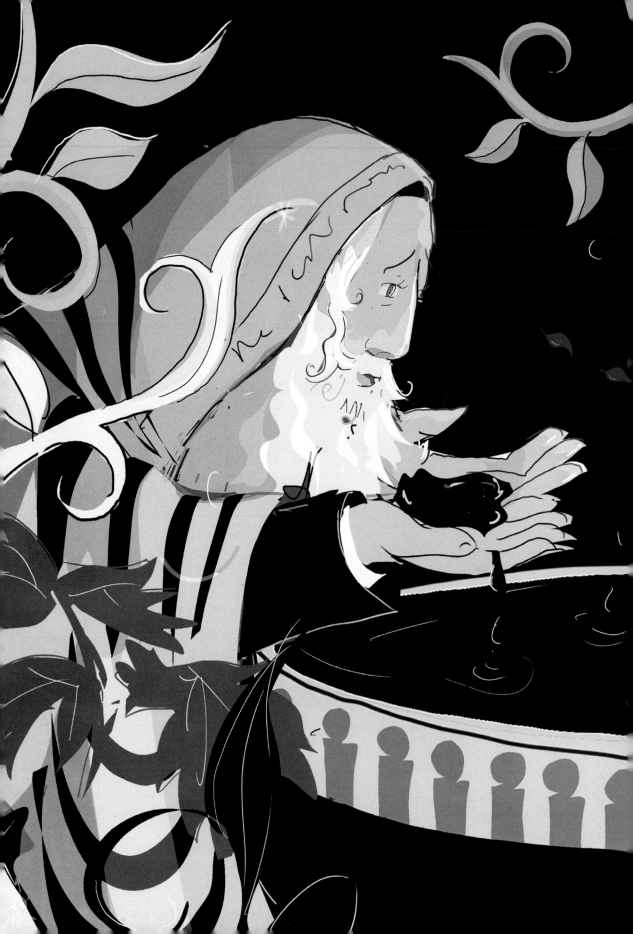

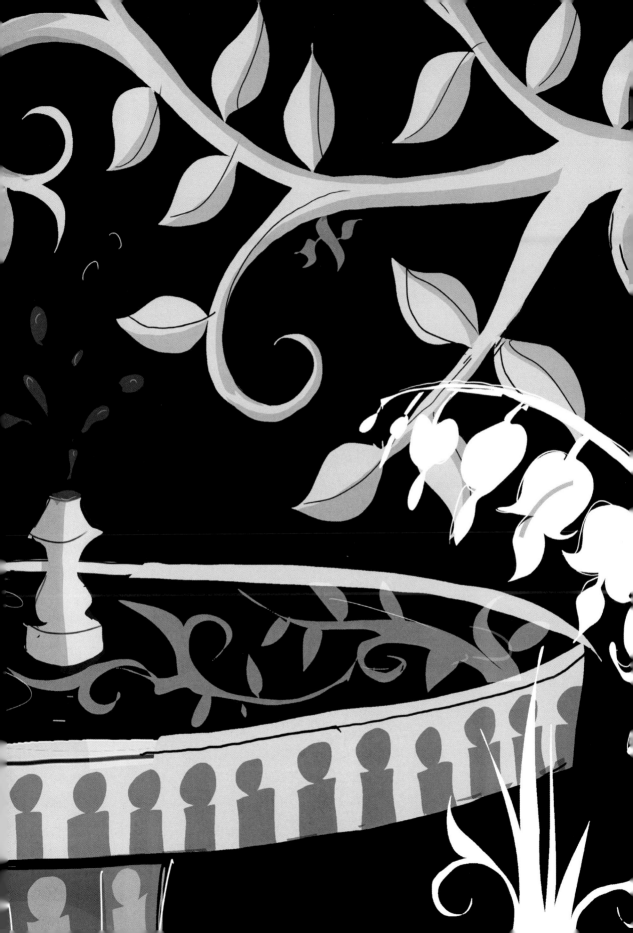

"And when he returned
from the *Pardes*," Abba said,
"he was wise beyond measure,
for he had practiced
all four ways of knowing:

פשט—*pshat*—superficial,
רמז—*remez*—analytical,
דרש—*drash*—experiential,
and סוד—*sod*—mystical. . . .

"In other words, from פשט to סוד."

"But he was wise before he entered,"
said Malkah, as she always did.

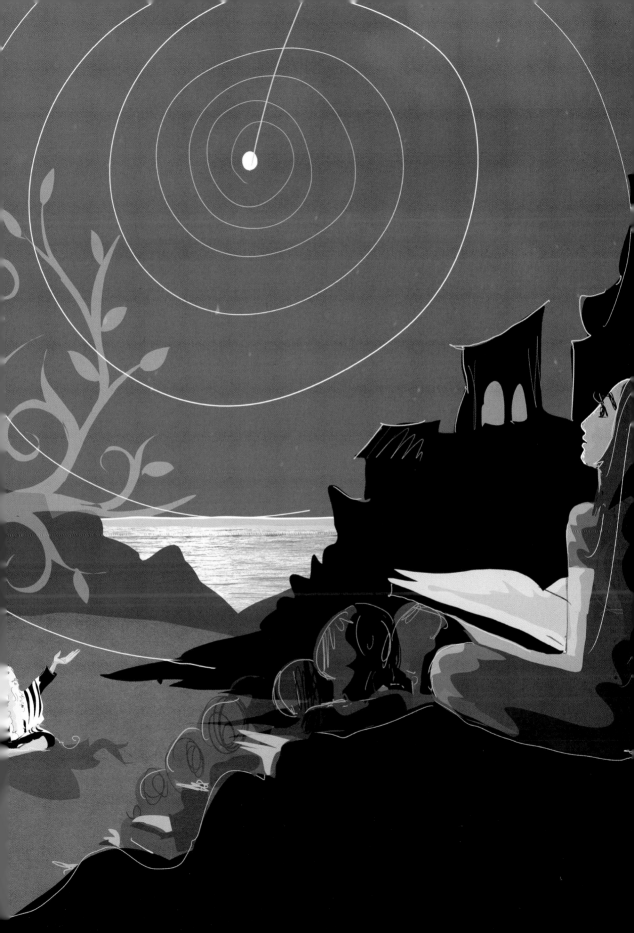

"True enough,"
said Malkah's father.

"For פשט, the physical world,
is there to hold open the door
that leads to סוד,
the mystery."

Malkah longed to see this
for herself.

But she could not tell the difference
between the garden of the physical world
and the hidden Garden of Paradise.

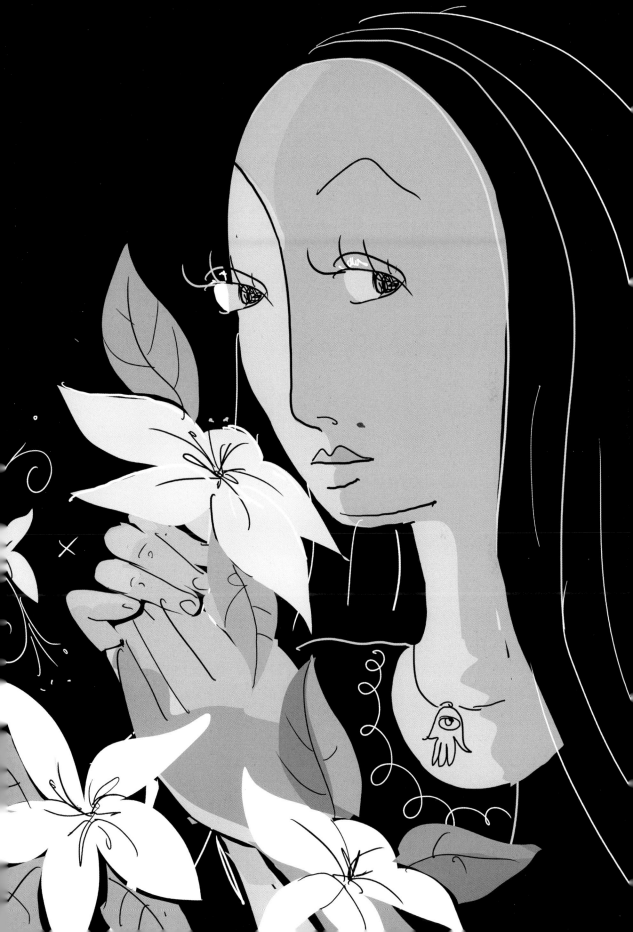

"So," said Malkah,
"if we learn our Aleph-Bet
and love the letters—

"If we study Torah
and enter *Pardes*—

"If we make a garden,
and don't steal the cuttings—

"If we enter in peace
and leave in peace—

"What happens then?

"Will what is broken
be made whole again?"

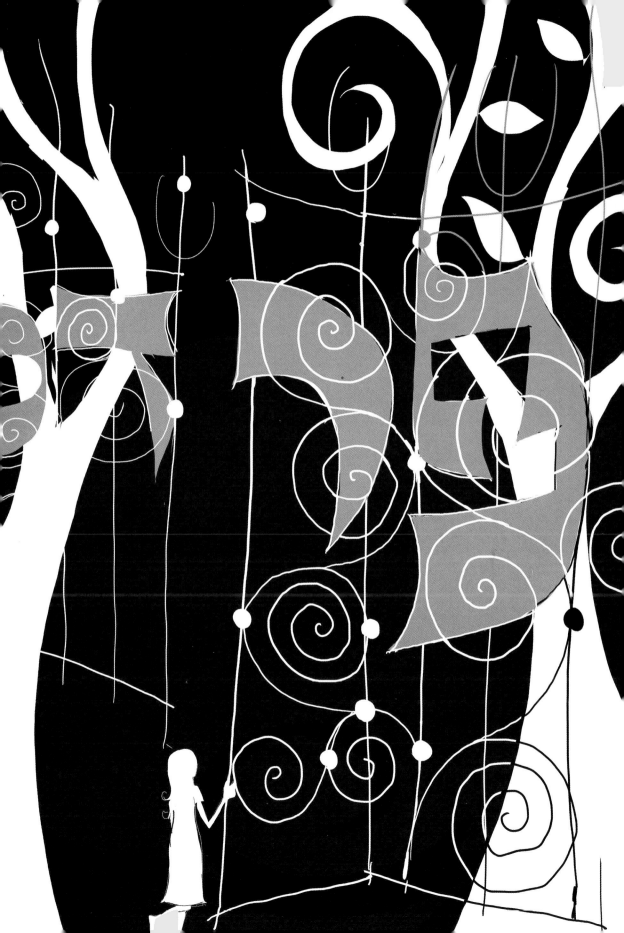

"Such a blessing,"
her father said,
"to have a daughter
who can ask such questions."

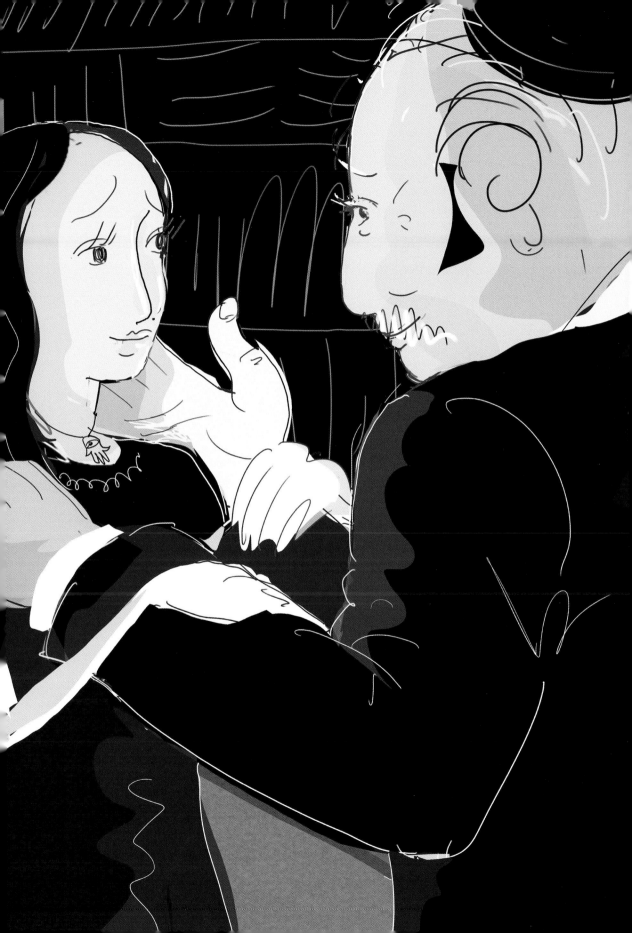

Malkah looked
at her father.

And for the first time,
she realized
that he did not
have all the answers.

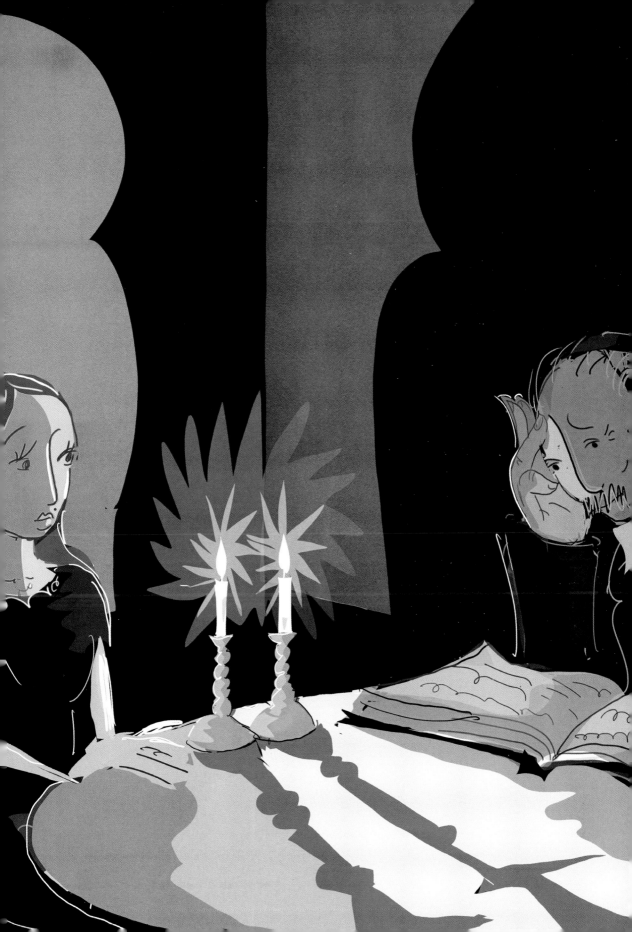

All that study,
and he could not mend
the things that
were broken.

Not even
such a small thing
as a broken
heart.

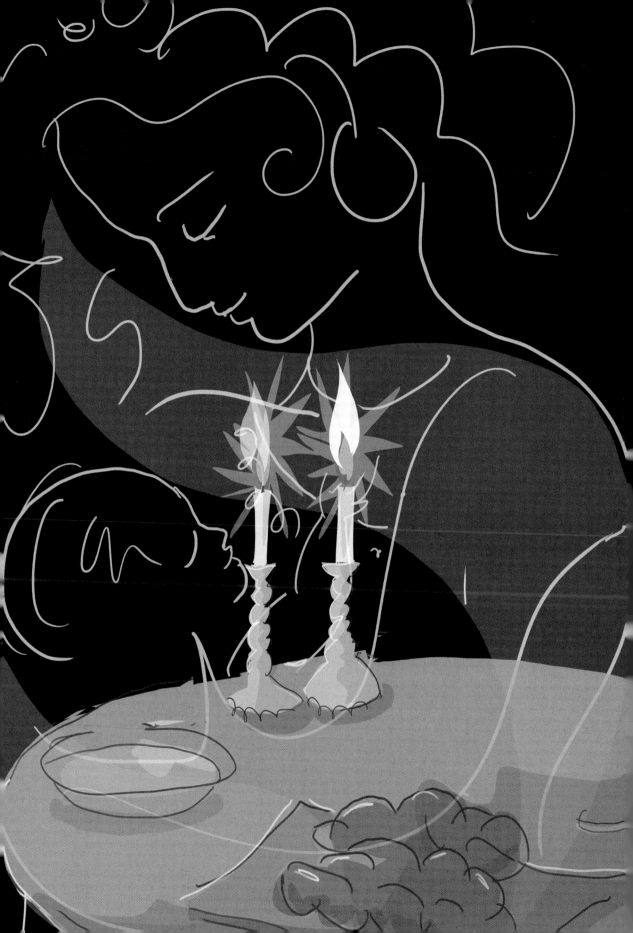

And
suddenly,
Malkah was
tired of sages,
tired of Torah, and
tired of crumbling old books
in the dusty old library.

Torah seemed no more than
a bunch of old stories
—good stories—
but stories,
nothing
more.

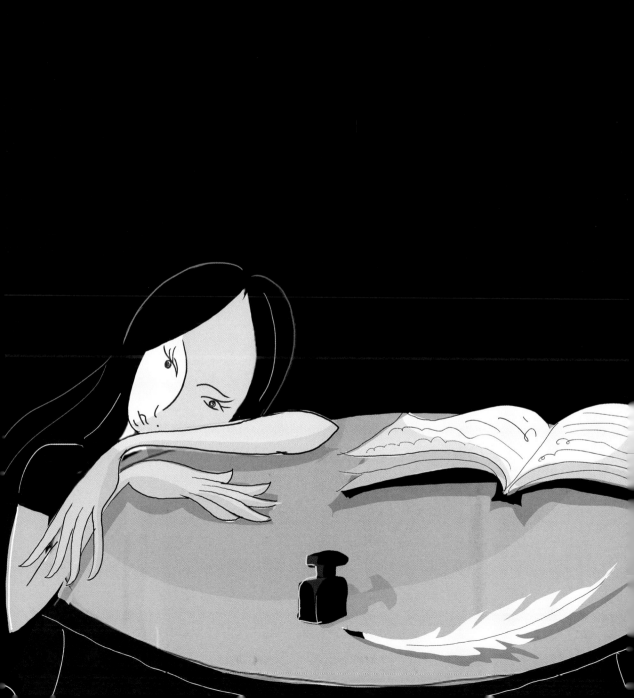

Malkah
had reached a door
she was afraid to open.

But she heard a voice saying,
"Questions open doors,
Malkah—"

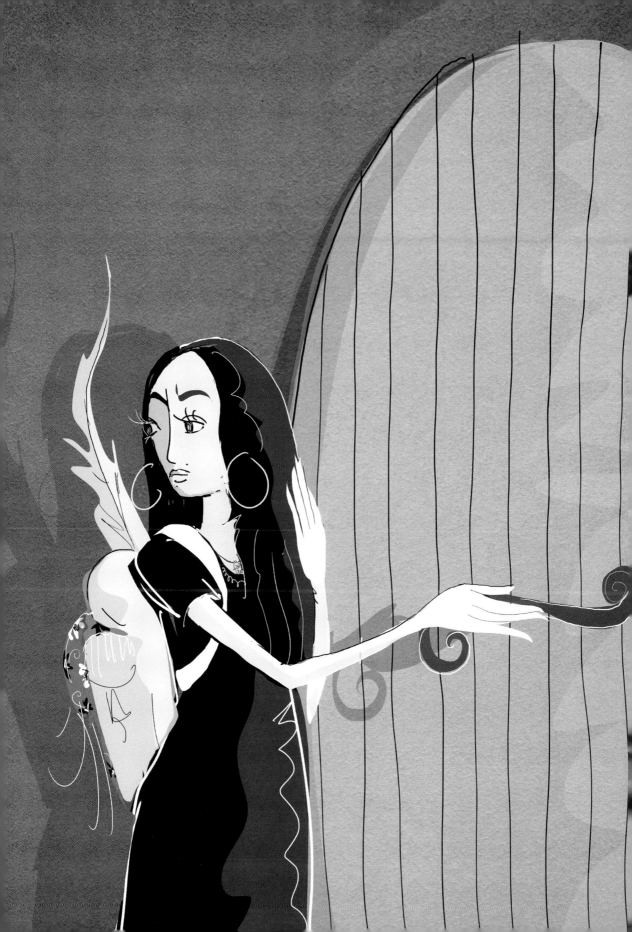

And that voice
was her own.

It was time
to leave
her father's
library.

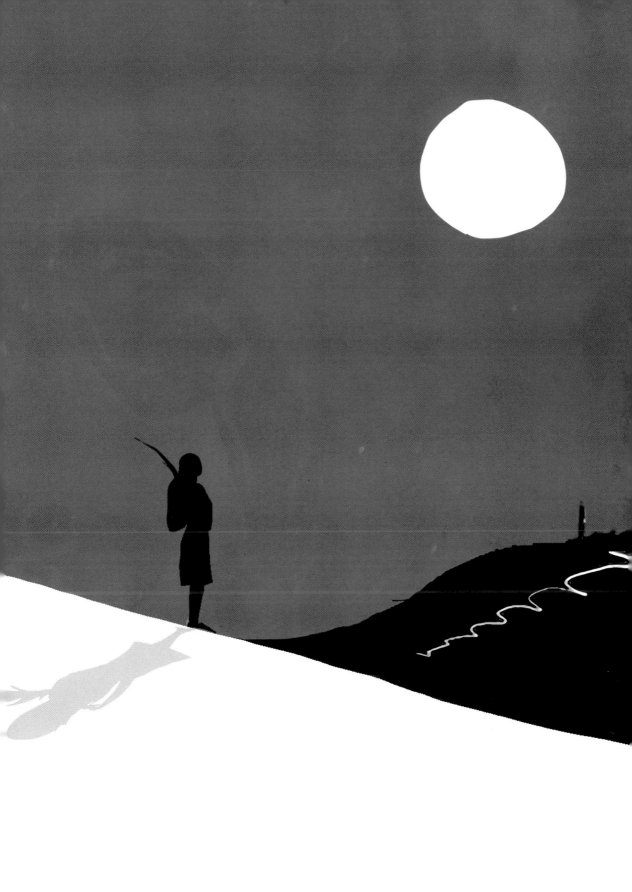

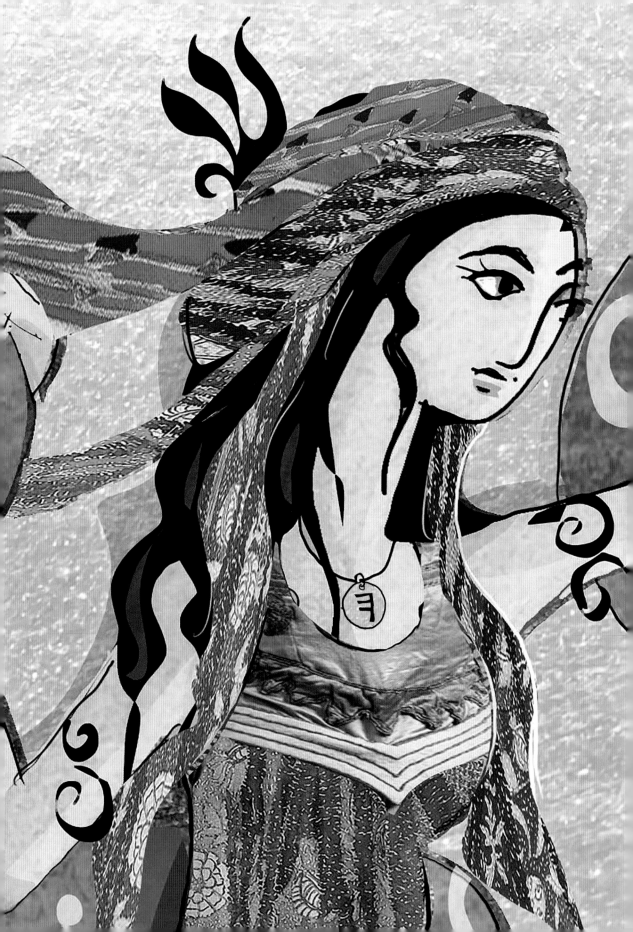

GODS
AND OTHER
BROKEN THINGS

MALKAH HEADED
as far away from home
as she could imagine.

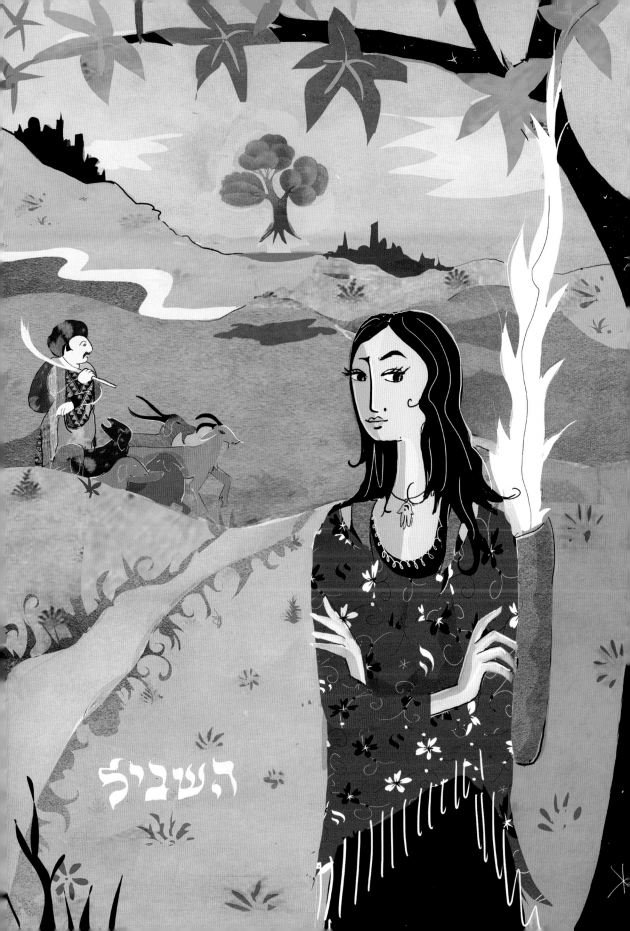
השביל

But all she could imagine
was the city of stone,
city of beauty—
the holy city,
Jerusalem.

And there,
Malkah felt at home.

It was as if she'd never left
her father's library.

And so—

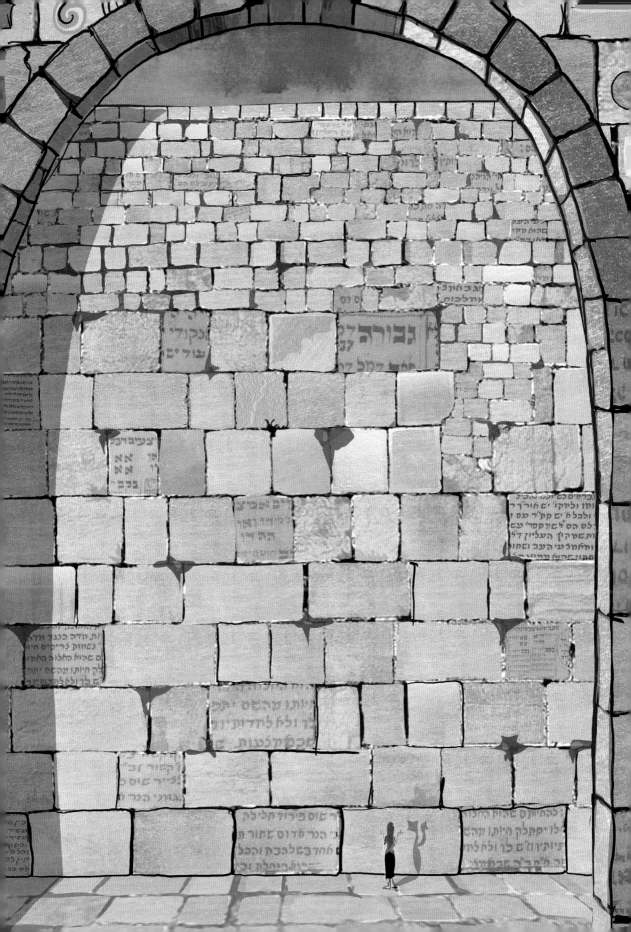

Malkah tore herself away
to find the rest of the world.

She came to the city of light—
for where else would she want to go?

It was not what she expected.

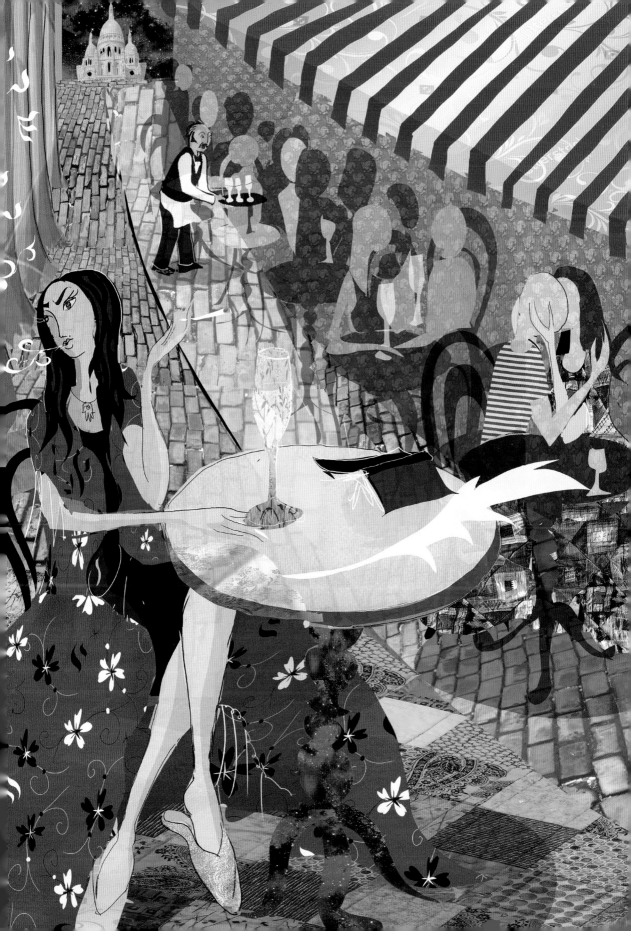

Everywhere
she looked was a
reminder of a mother
she could not remember.

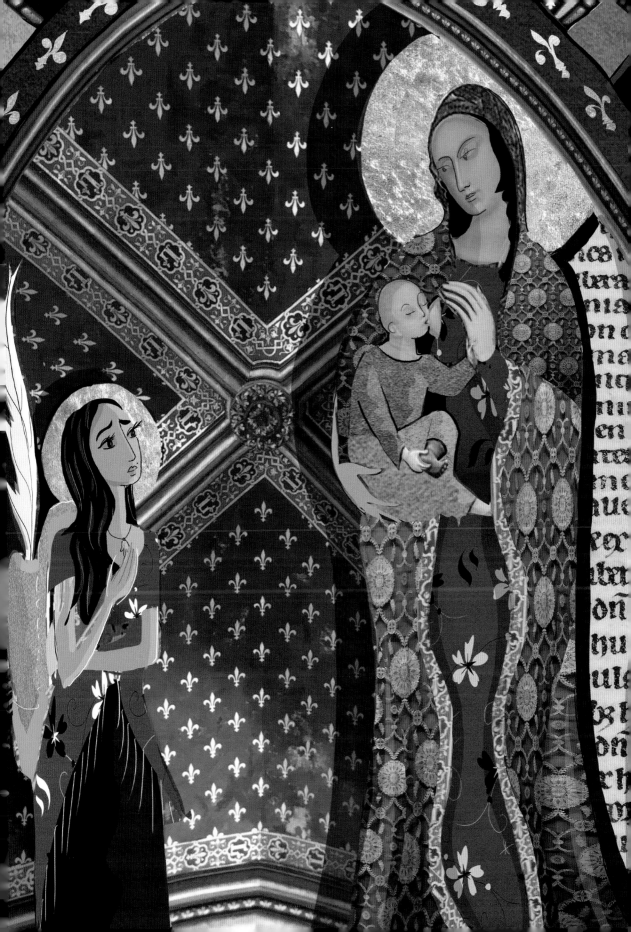

She tried simple things—
taking notes,
writing poetry,
drawing pictures,
practicing her letters.

But she could not think.

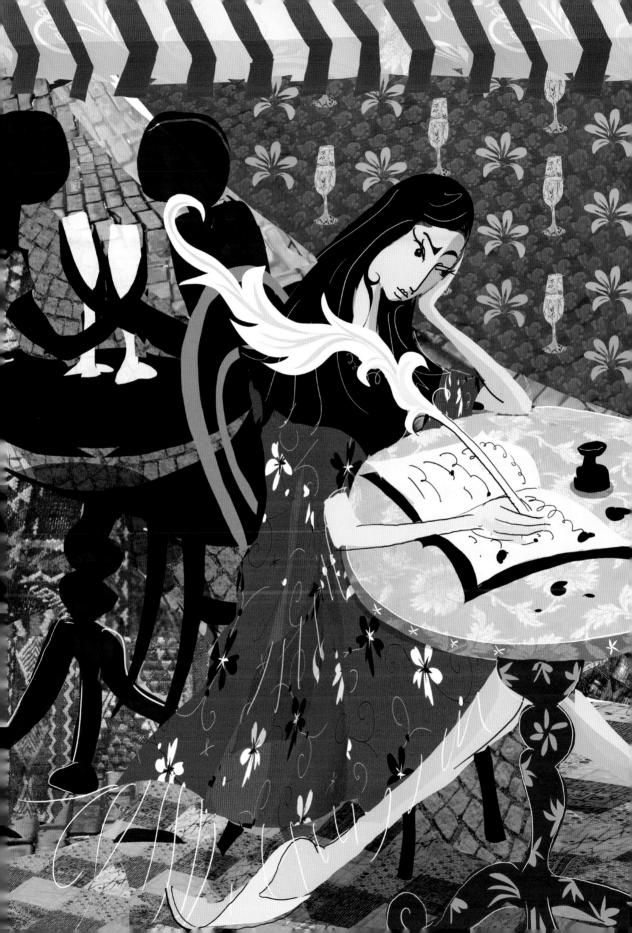

And so
she moved on.

She found herself on islands
made of molten fire,
shattered pumice,
and clouds
of ash.

Could this be, Malkah wondered,
where the original thread of light
had descended and
hit the earth?

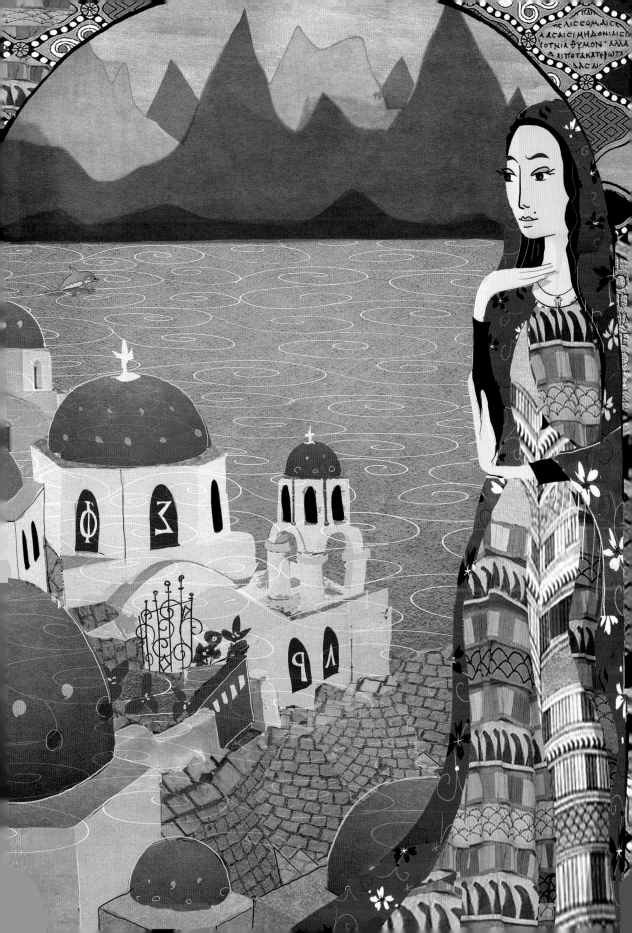

Here, Malkah thought,
she could be like the First Sage,
and commune with nature.

But for her,
nature was more enticing
when it stayed plastered on
the ancient walls of crumbling palaces.

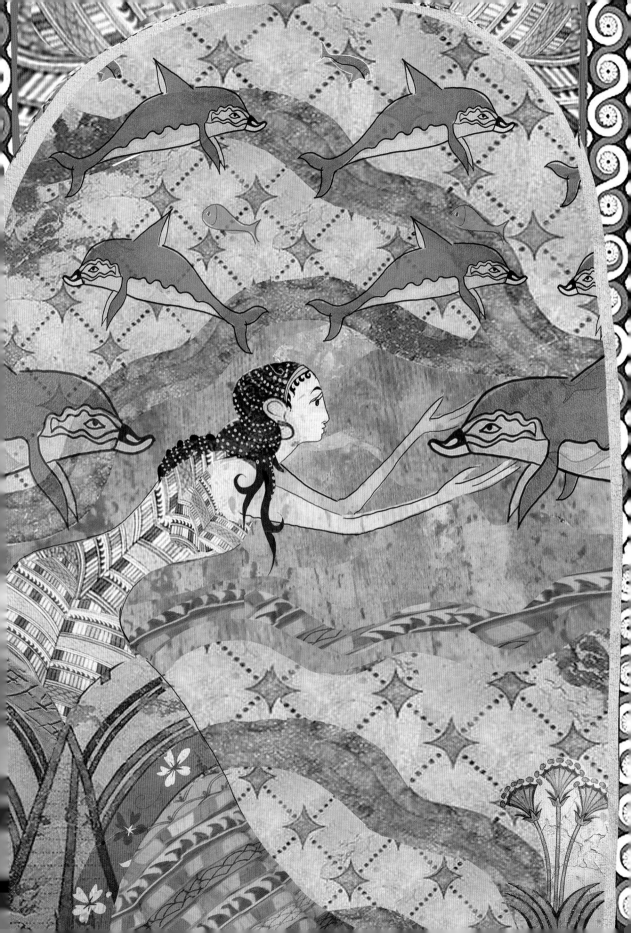

In the land of the ancients,
she could touch her own history,
and the histories she had read
when she was a child.

Here, too, she breathed in
the dust of many ages.

And it was as familiar
as the dust of the crumbling old books
in her father's library.

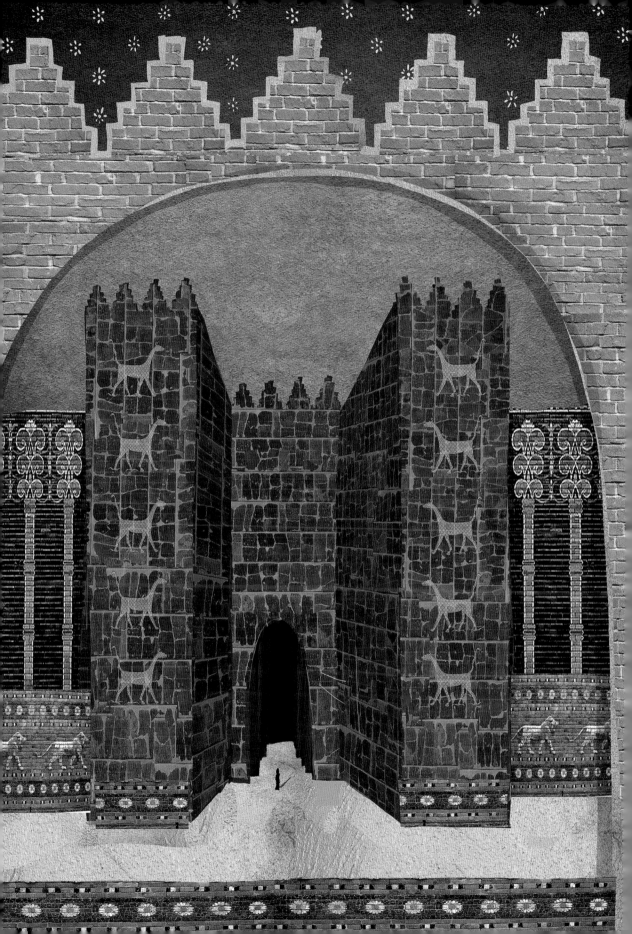

She thought she should study—
study more—
study everything—
just as the Second Sage
would have done.

There was so much
more to the world
than could be contained
in any library.

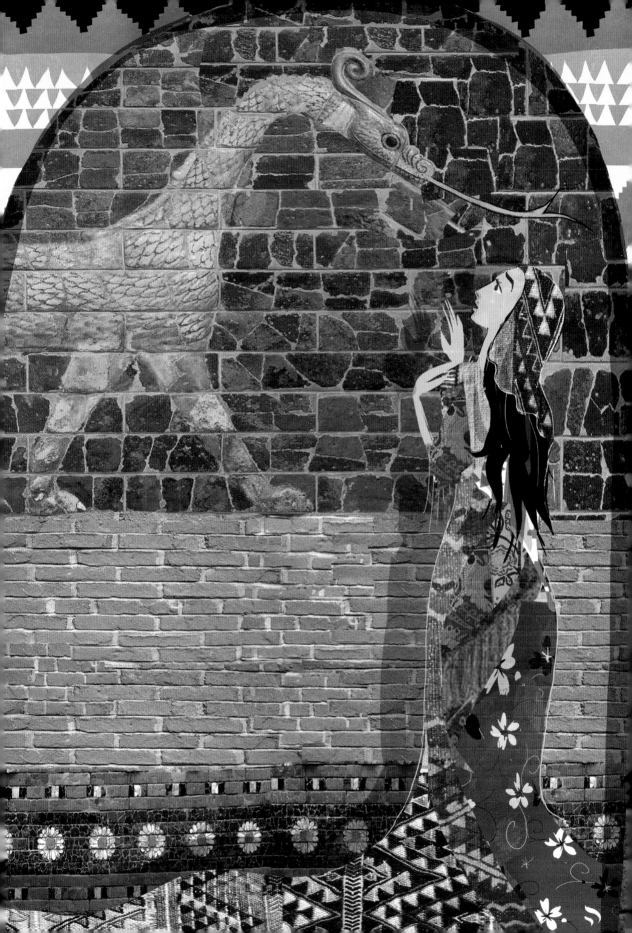

There were even those
who sought to close their eyes,
follow an inner path,
and come closer to the source of all
than any book could reach—
just as Malkah imagined
the Third Sage
had done.

Suddenly, she was no longer satisfied
just to *read about*—

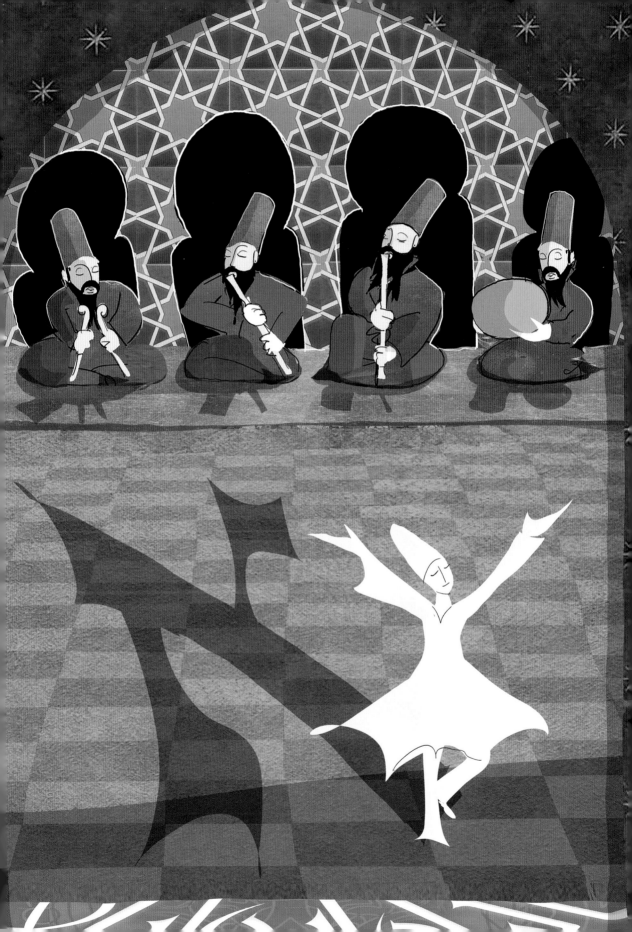

Like the Third Sage,
she felt compelled to *do*.

Maybe she could *feel*
the beginning of time—
the beginning of everything—
if she could just move
like a thread
of light?

Malkah tried very hard,
but she could not do it.

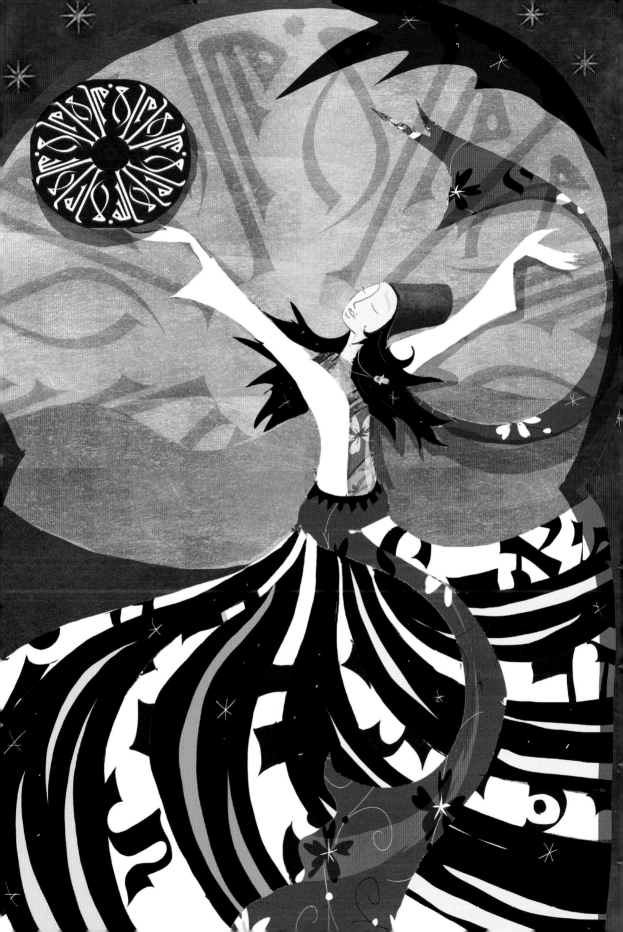

Or maybe, through silence,
she could ascend into *Pardes*
like the Fourth Sage, Rabbi Akiva, had done.

Malkah held her breath
and tried to sit
very, very
still.

But she could not concentrate
and she could not breathe.

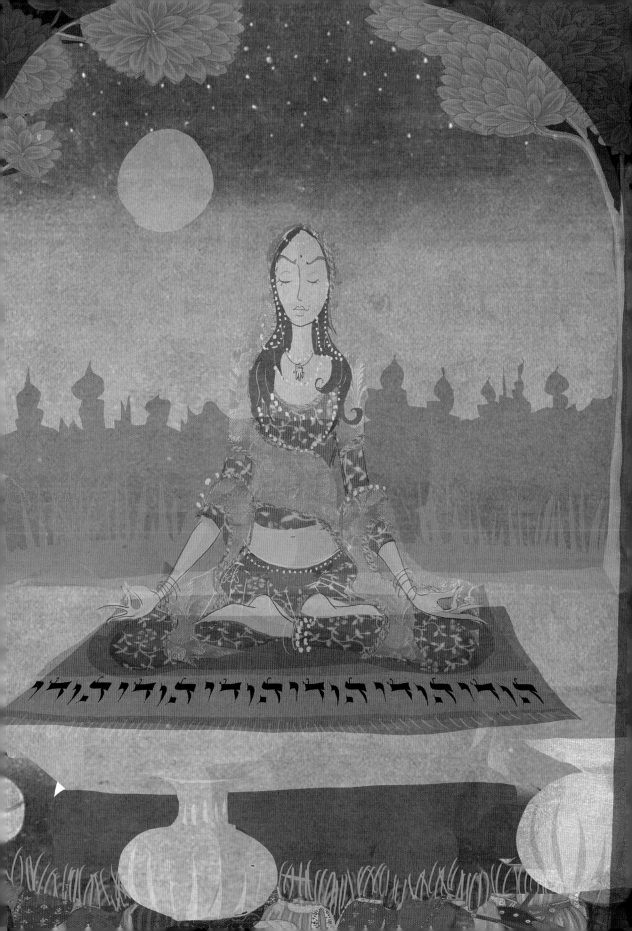

Nowhere,
she decided,
brought her closer
to understanding the source of all
than did her father's library.

And so Malkah turned around
and headed back to where she belonged.

But on her way—

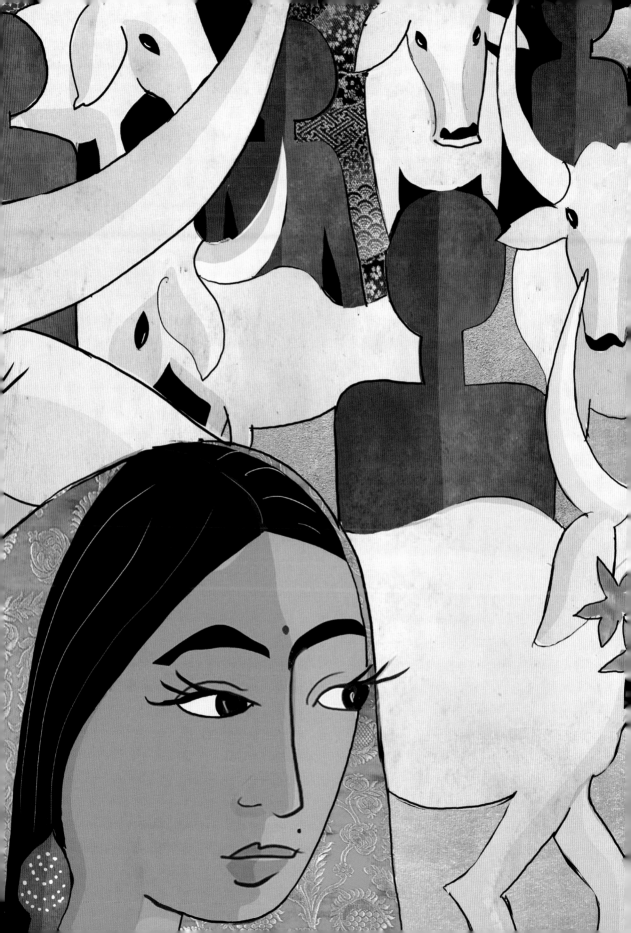

She came to a
vast desert.

And there
she stopped.

Suddenly, she felt
more at home
than she had
ever felt
before.

She could not
explain it.

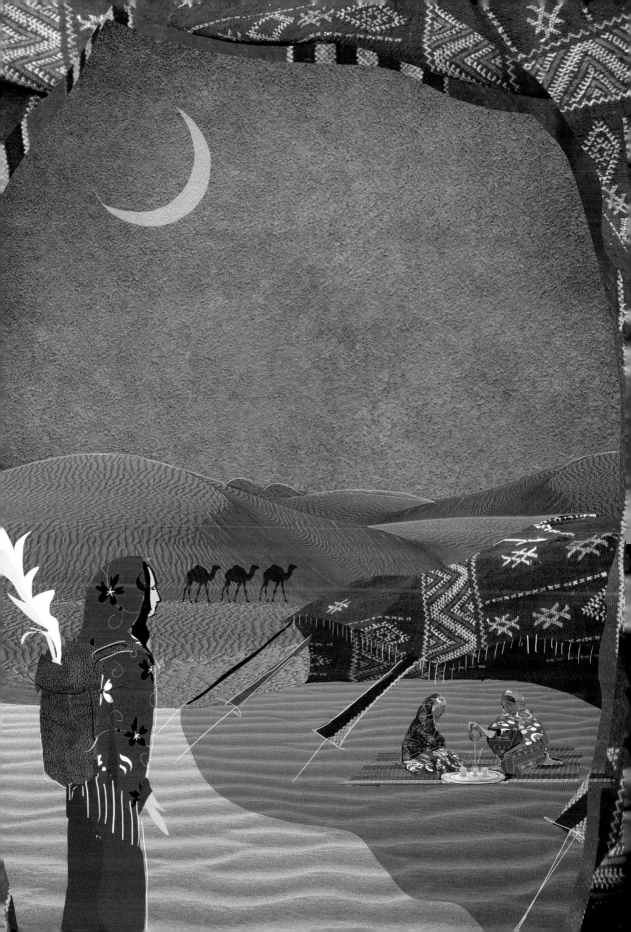

There were women there,
and they taught her to sing
and to dance, to work and to play.

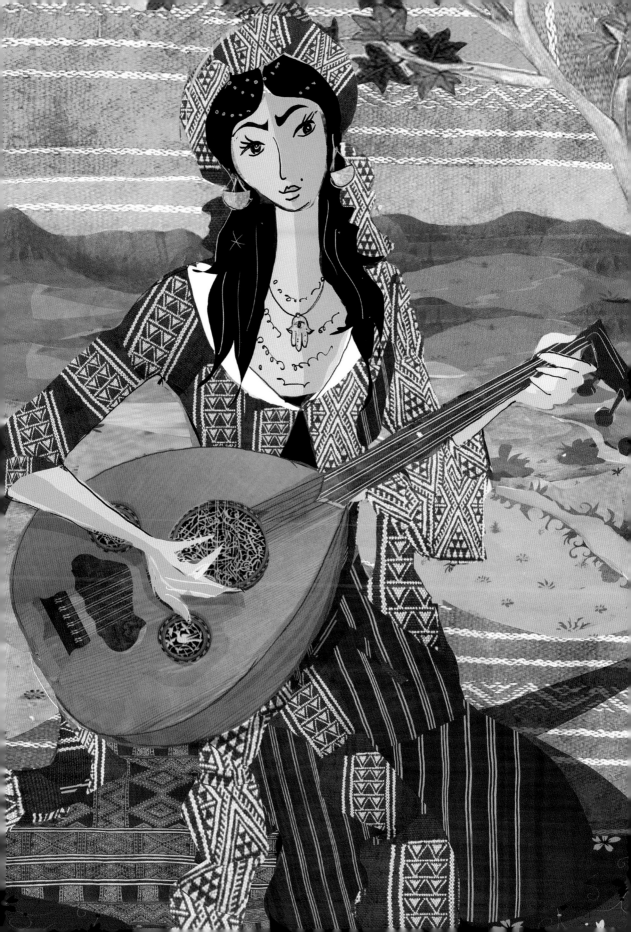

And above all else,
she learned to pray.

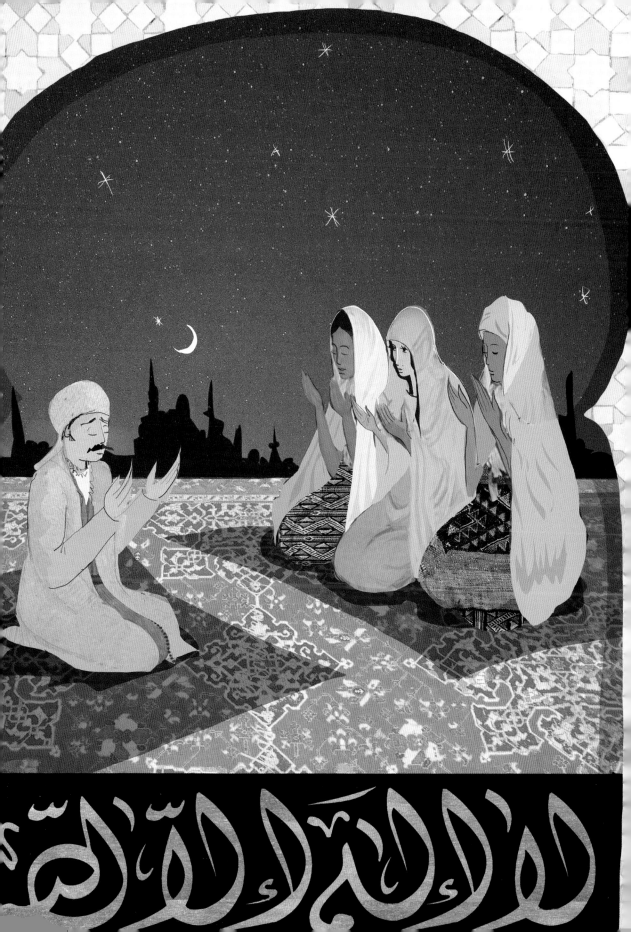

Malkah stayed
for a long, long time.

For the first time in her life,
she did not feel alone.

So why, why did she ever leave?

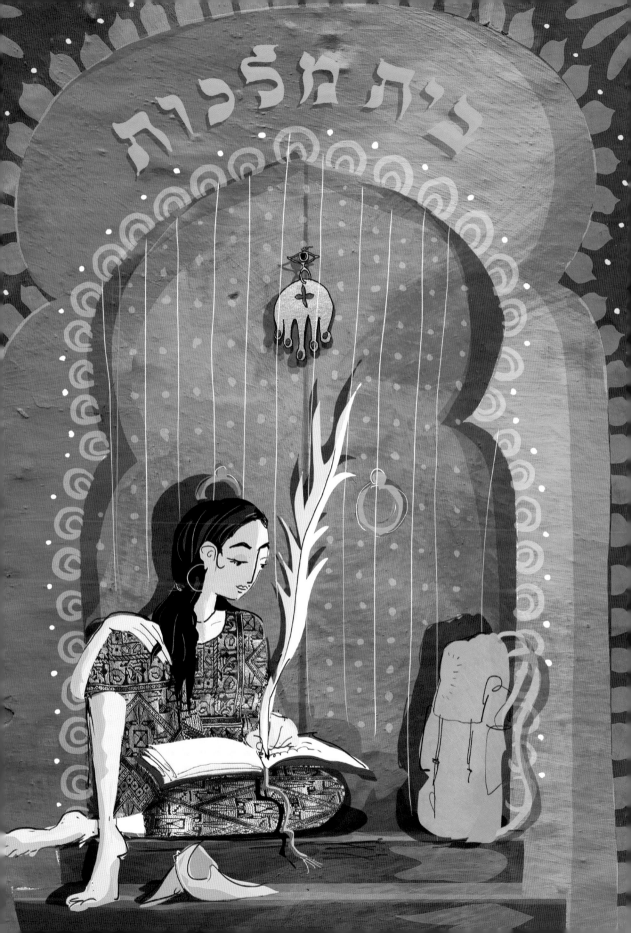

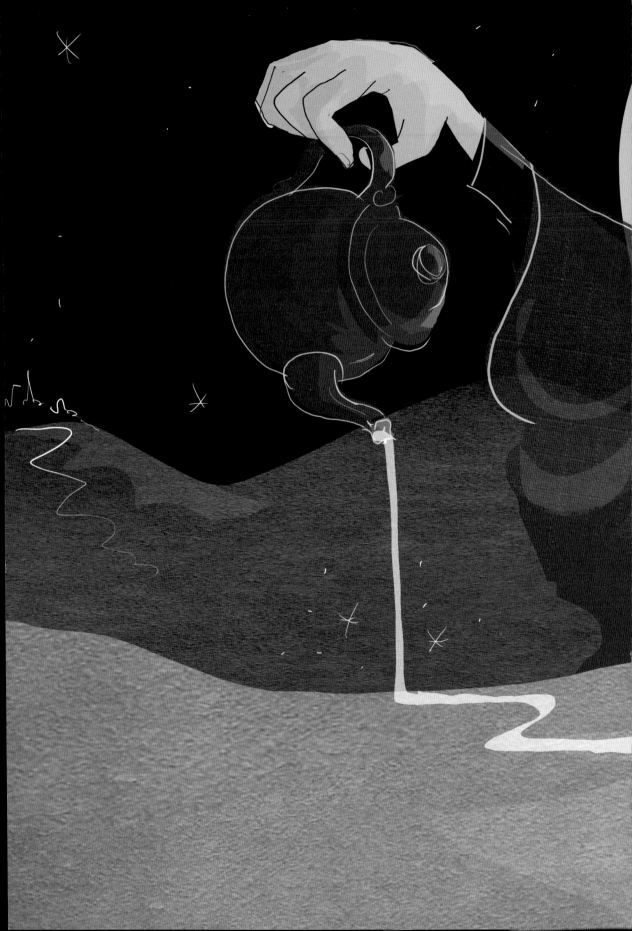

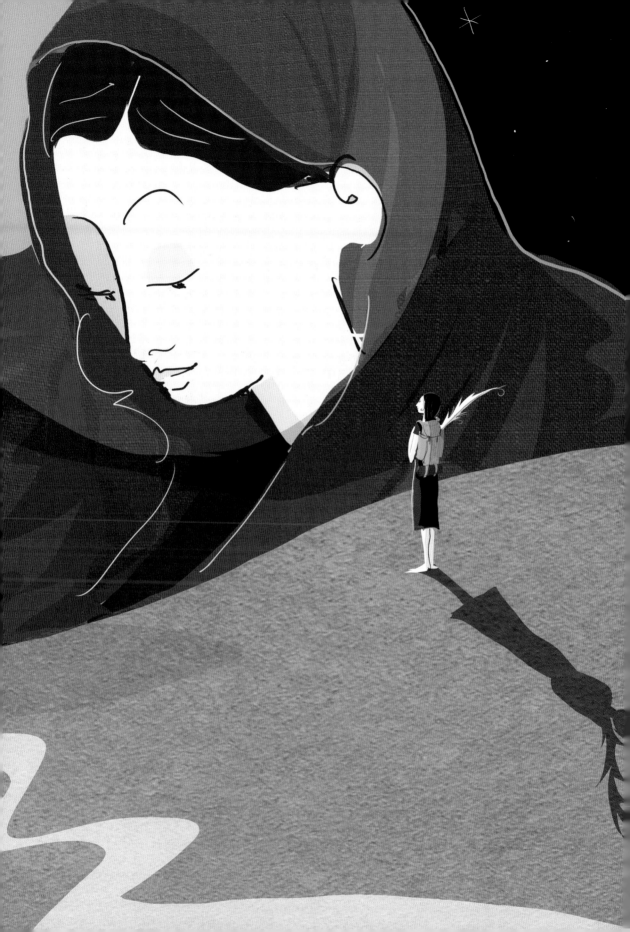

Perhaps it was still libraries
and books that called to her the loudest—
ancient alphabets, unfamiliar myths,
and fabulous tales.

And maybe it was creation stories most of all
that beckoned her, like the ones
she had loved as a
small child.

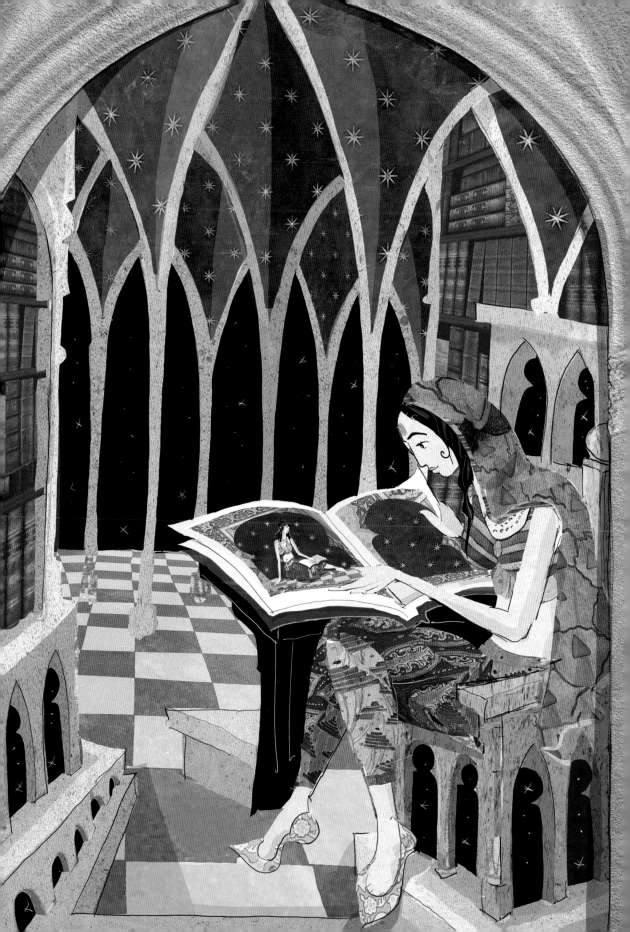

Malkah no longer cared
whose stories were right and
whose were wrong.

She cared only that
people everywhere sought
to find their own beginnings.

And so Malkah began to dig,
trying to piece together
the fragments of the past.

And she forgot that she was on her way home
to see her father, ask him questions,
and consult the crumbling old books
in his dusty old library.

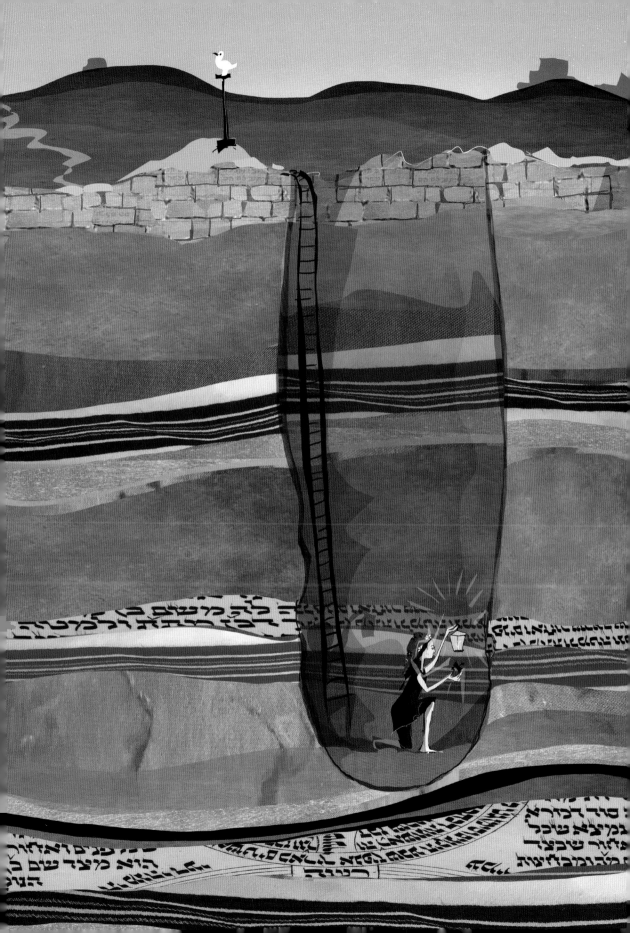

She had read so many stories
of the patriarch Abraham,
when he was a child
in the city of Ur.

And of Terah, his father,
who made statues for pilgrims
who visited the holy
ziggurat of Ur.

And now, here was Malkah—
looking down at the rivers
that flowed from the shoulders
of the old gods of Ur.

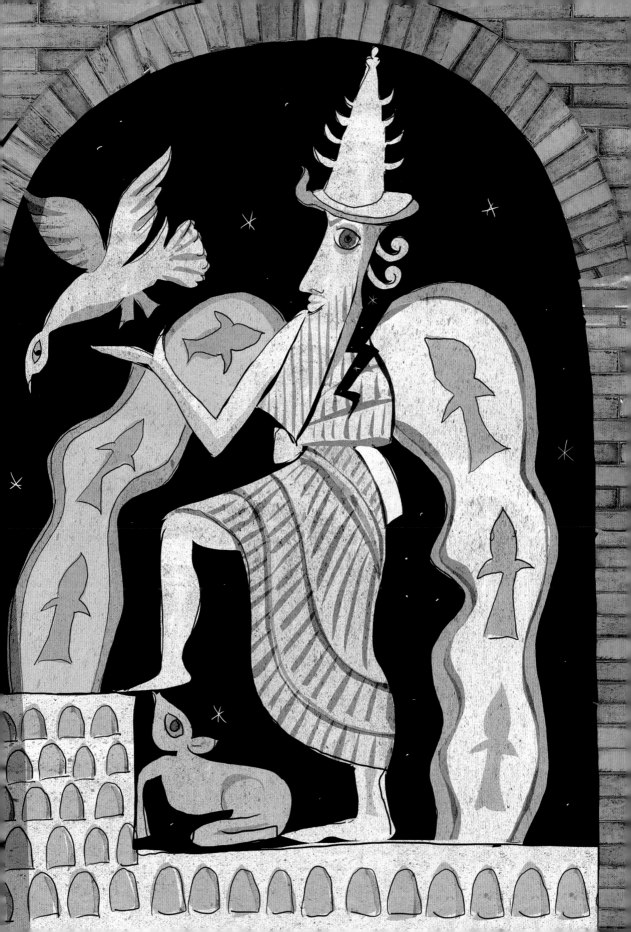

And she began to see the gods
through the eyes of the peoples
who lived in those lands
in Abraham's time.

When nature thrived,
the gods were praised,
and when nature languished,
the gods were blamed—
for in those days
the gods and nature
were the same.

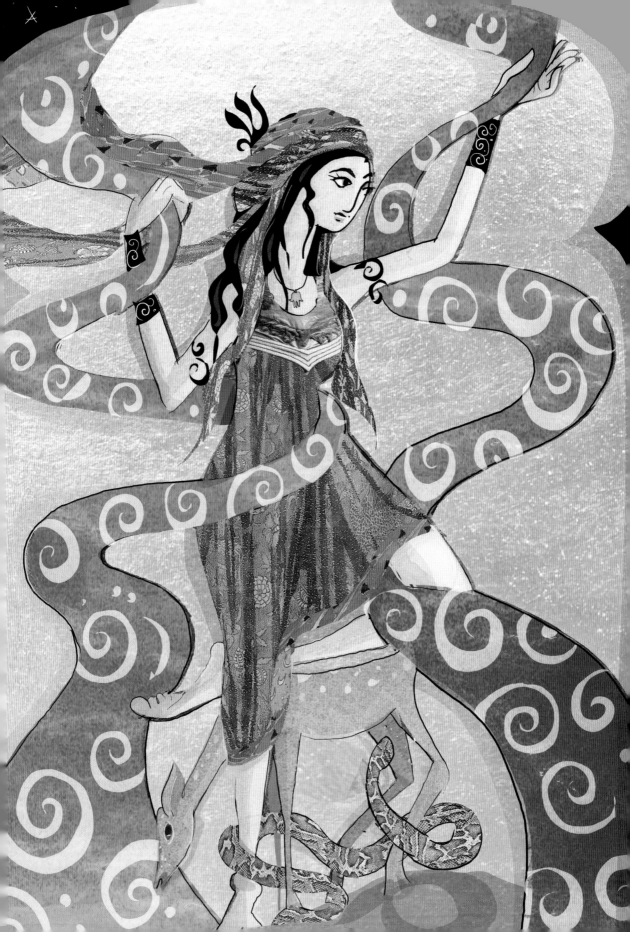

In such an arid land,
Malkah thought,
the big rivers seemed
the most powerful
forces of nature.

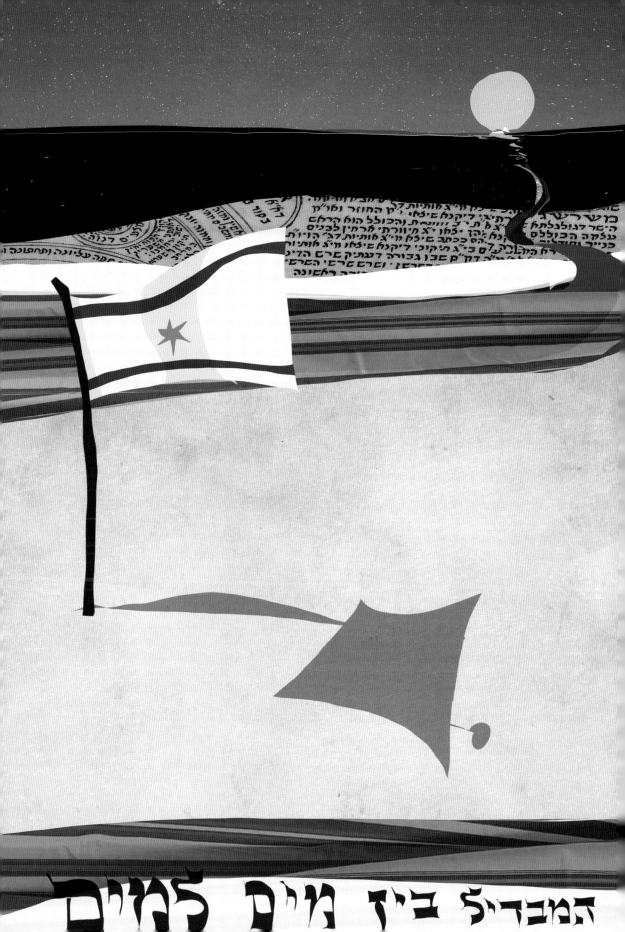

The names of the gods, they changed
as they moved from place to place.

In the Holy Land,
four gods had ruled supreme,
two male and two female.

Malkah found El, the Creator,
powerful and strong,
king and father to all.

In ancient times,
he was the Sacred Bull,
worshipped, painted,
and adored.

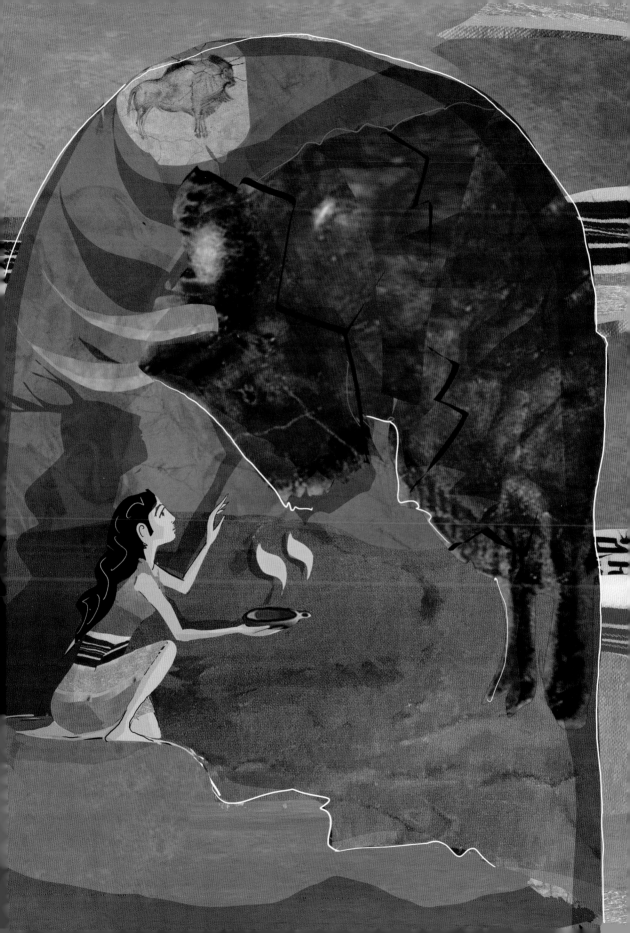

But El grew lazy and tired of creation.

He became passive, remote, and unconcerned.

And man came and tamed the bull,
beat him for sport, and consumed his flesh,
absorbing what power remained.

And what kind of god is that?
thought Malkah.

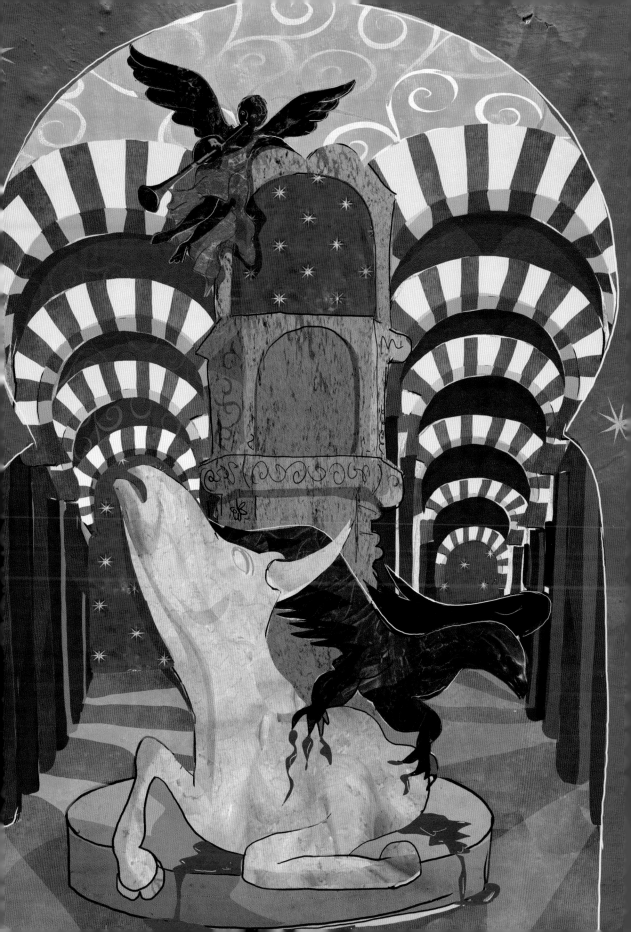

She found Athirat—
Great Lady of the Sea,
partner to El in Ugarit,
mother to the lower gods.

Astarte to the Phoenicians
and Attar to the Hittites.

She was Isis to the Greeks
and Au Set to the Egyptians.

Esther, Asherah, Ashtoret, Elath . . .

She was, root and stem, woman.

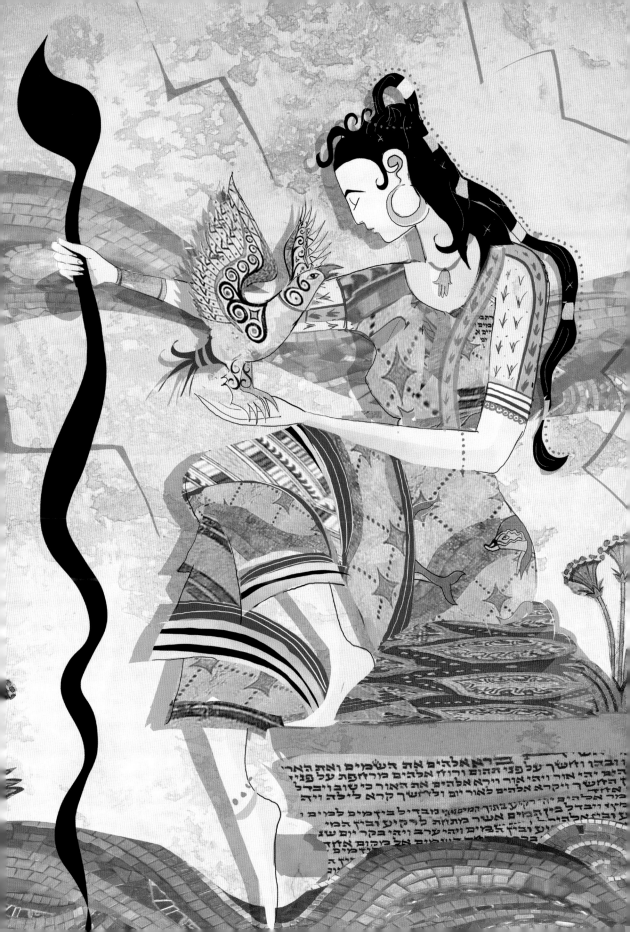

"את *aht* not את *et*," said Malkah,
holding shards of the broken goddess.

"את—you!"

בראשית ברא אלהים את
Bireishit bara Elohim aht!

Was it you, Divine Mother,
in the beginning?

Was it you that I lost?

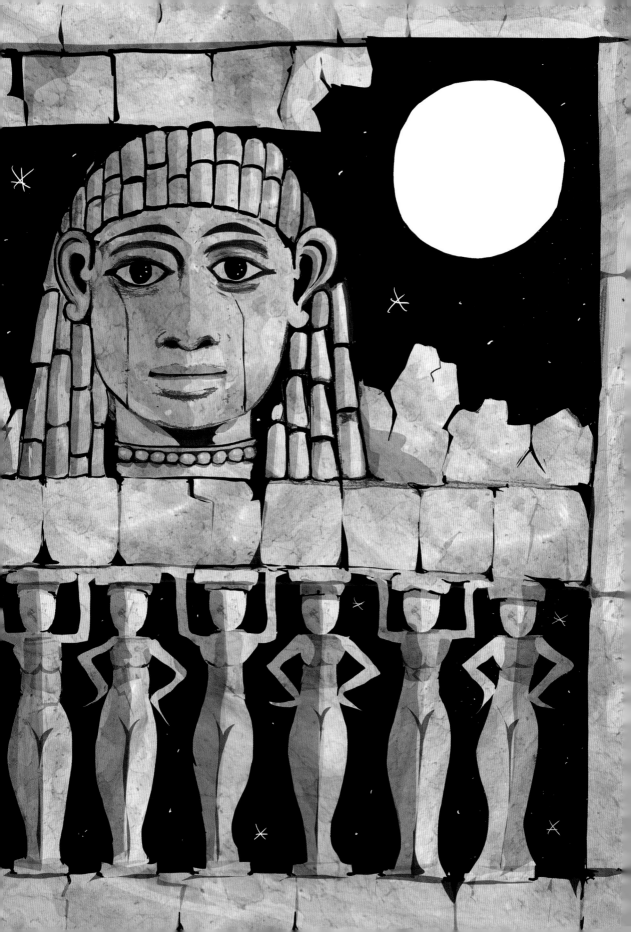

But Athirat,
like El, grew tired of those she had birthed.

Except for one—her son—
whom she loved with a special love
and protected above all others.

And, Malkah thought,
what kind of mother is that?

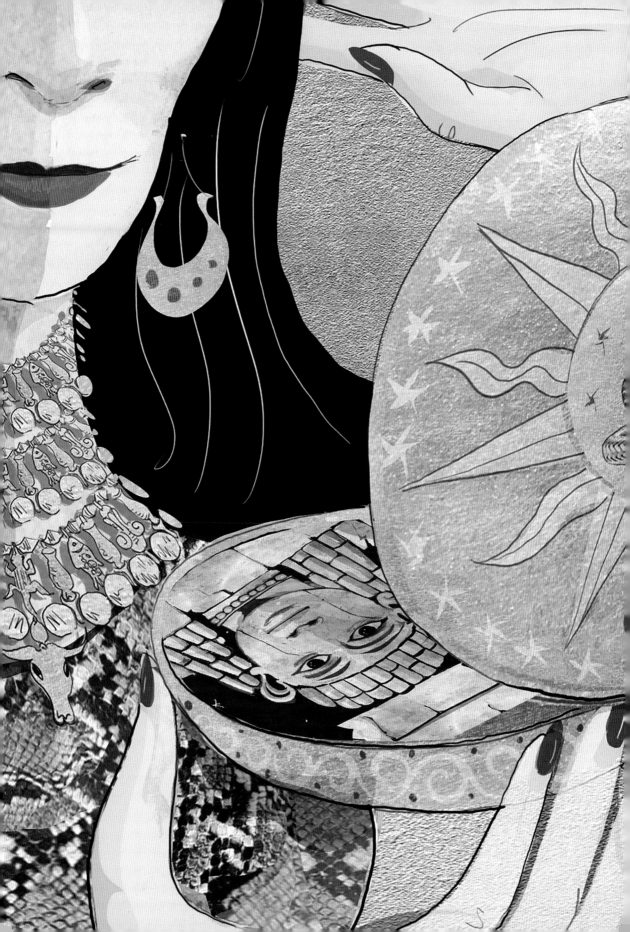

His name was
Ba'al, the storm god,
and Malkah found his statue next.

Son of Athirat, and her lover too.
He was the god of fertility,
bringer of rain to the thirsty land.

But Ba'al, the force of life,
was locked in battle with Mot, the god of death,
and the earth's fate was in the hands
of the two combatants.

The land would flourish and produce
or face drought and famine
in accordance with the cycles of their battle.

And the people built temples and altars to Ba'al
to influence the fate of the earth.

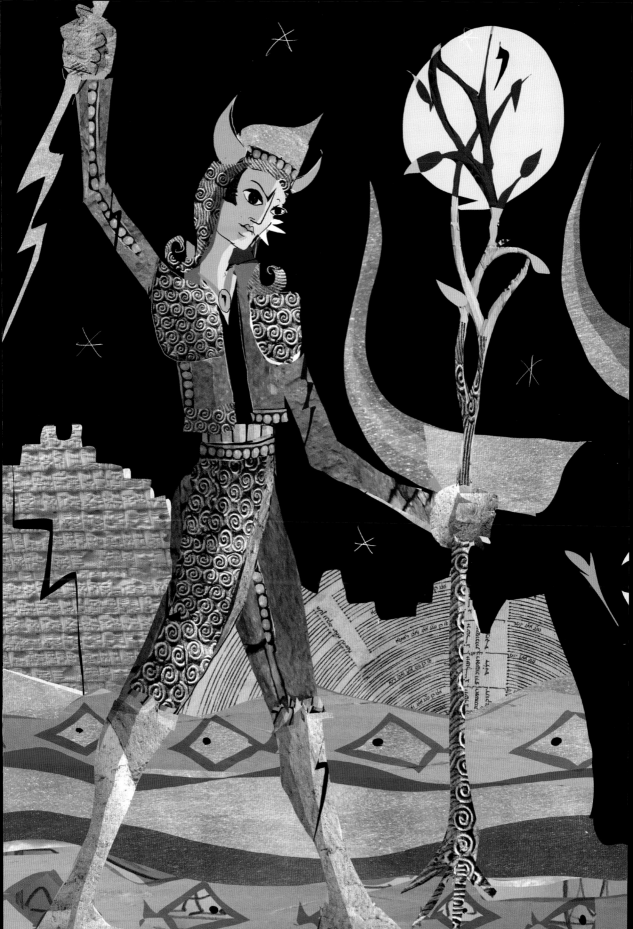

Malkah found Anat, sister of Ba'al—
and yes—her brother's keeper.

She was Inanna to the Sumerians
and Ishtar to the Akkadians.

Protector of wild things,
Lady of both love and war.

"What kind of young goddess was this,
with arrows and bow?"
some deities grumbled
in her own time.

But Malkah thought she understood.

Anat was loyal and fierce,
youthful and free,
and she stopped at nothing
to protect those she loved—

"Now I understand the gods,"
Malkah said to herself.
"I want Anat to be me."

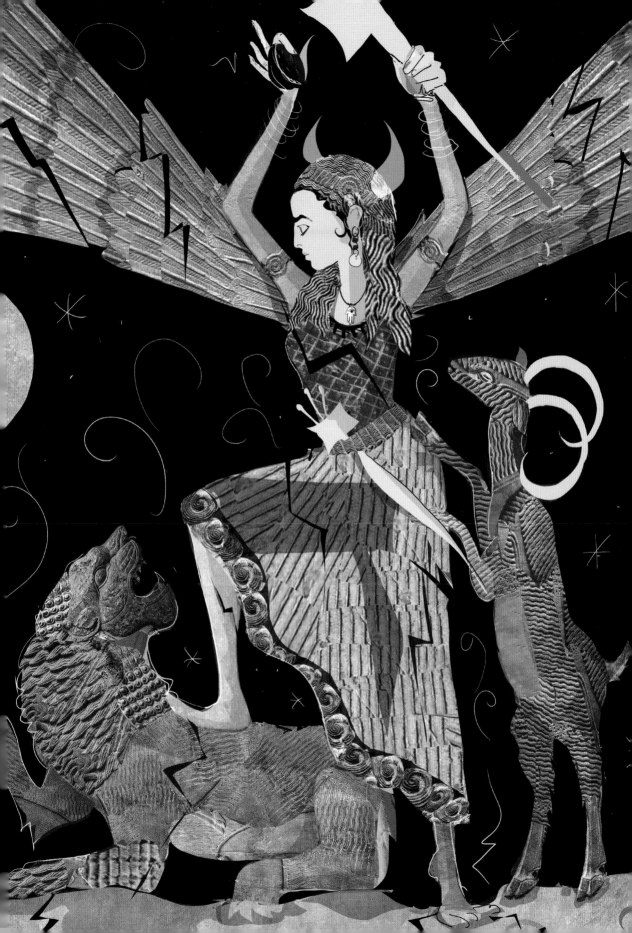

But in the tales, the gods,
they argued and fought.

They loved
and they cheated,
and died.

So Malkah gave up on the broken gods,
as she longed for something that could not break.

She closed her eyes and drew her breath in,
and tried to breathe slowly out—
but letters and words tumbled out by themselves
until they slowed to find their own rhythm.

She smoothed down their feathers,
dipped her quill in black ink,
and discovered her role
in creation.

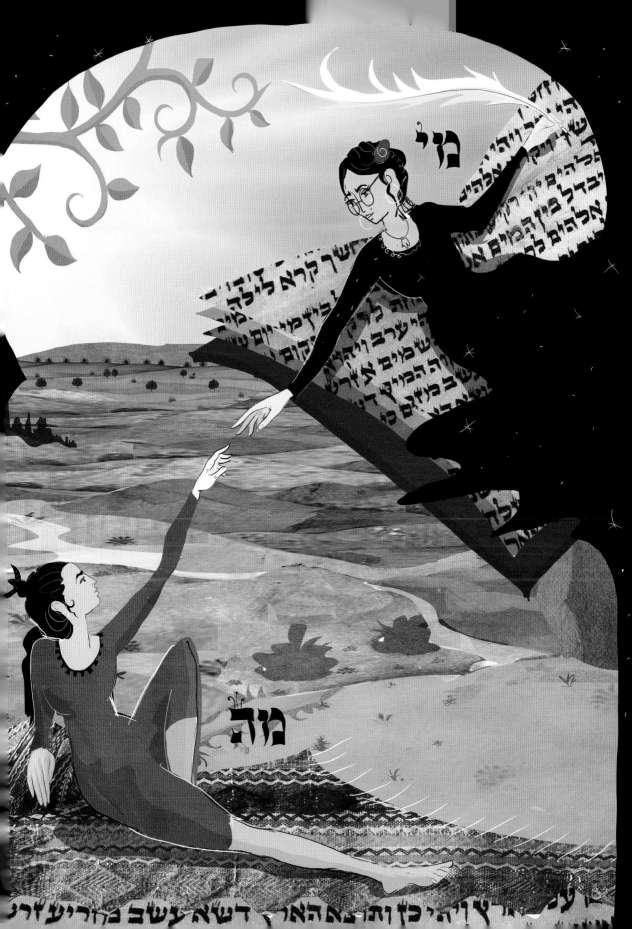

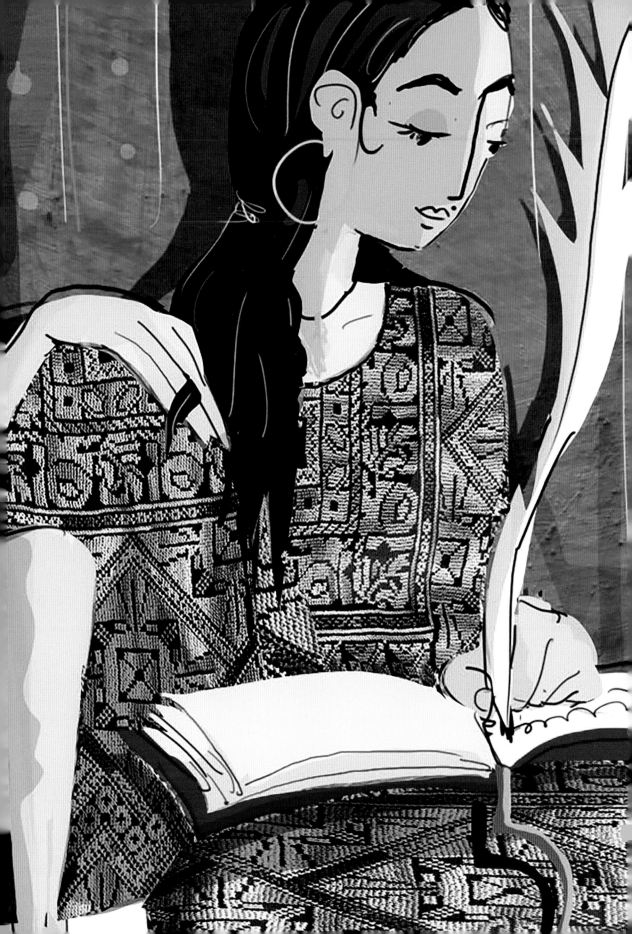

PART IV

MALKAH'S
NOTEBOOK

I KNOW YOU GODS
for what you were
and for what you have become.

Not just statues, idols, broken pots,
figments of our ancient imagination,
fragile objects lying there in the sand.

You gods, you did not disappear.

I see you deep inside and peeking out
from the letters in my quill.

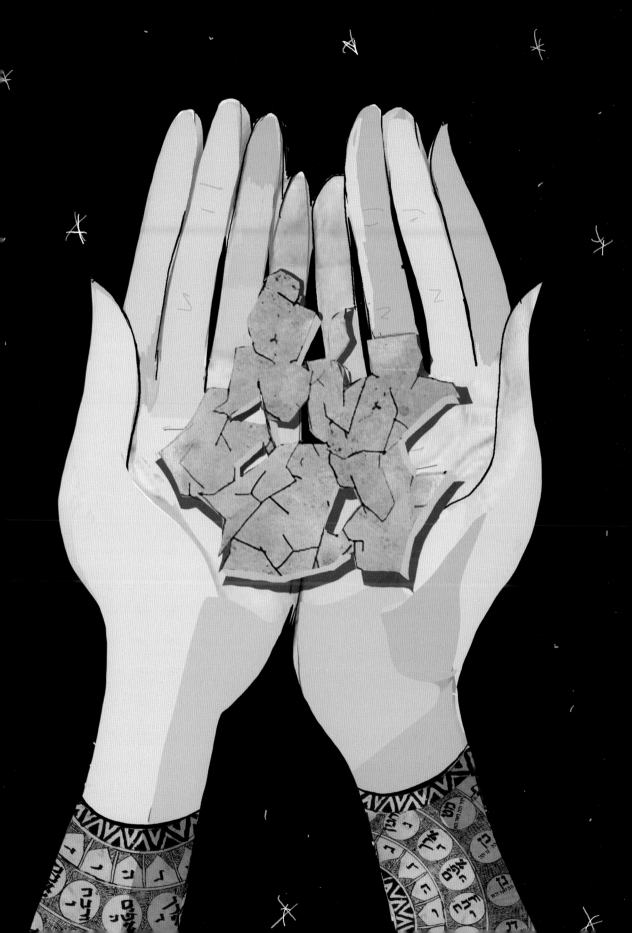

El, Creator—

Father and king,
ancient bull that you are.

You've got double ״ horns
just like the ״
in our prayer books
and prayers.

Whether
honored or dishonored,
El, you remain.

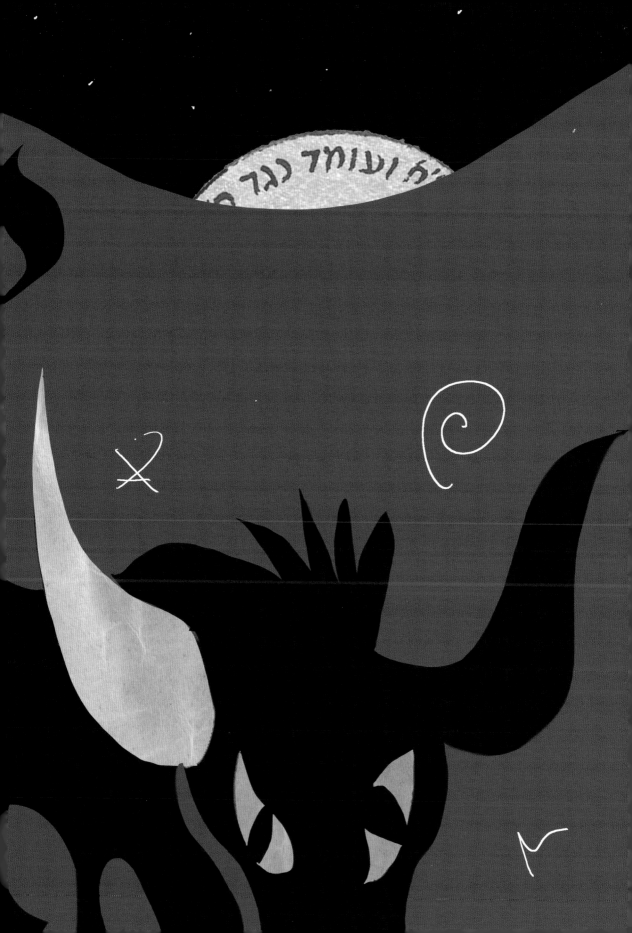

Athirat, Mother—

Your arms
should embrace me
like the upper letter ה does.

But Mama,
you're gone,
and they don't.

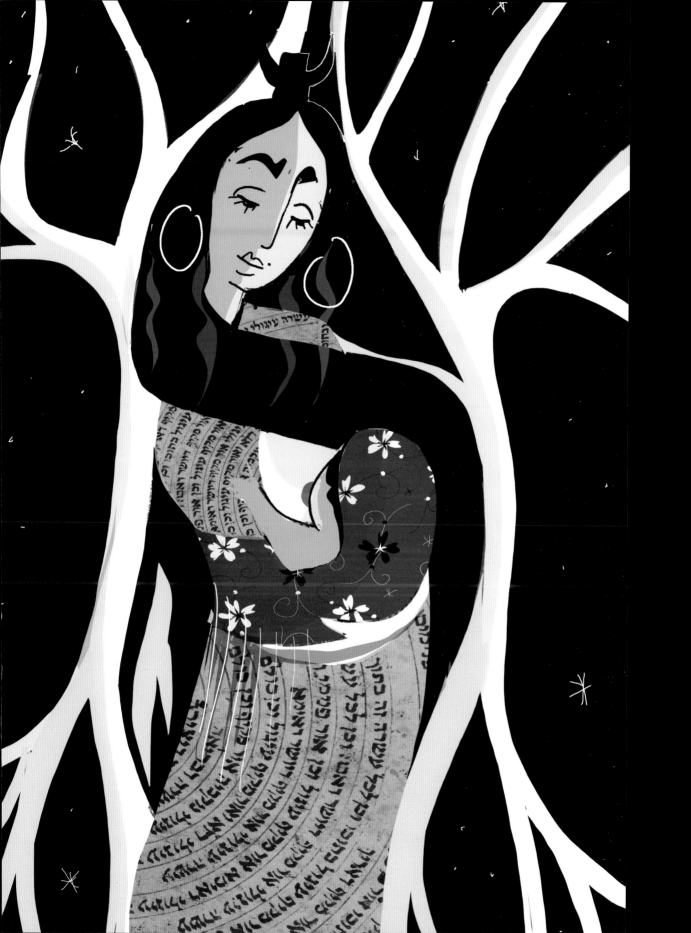

Brother Baʾal—

Standing upright and tall,
always in love,
the virile young ו.

You make stories flow, or rage if they need to,
that's at least one thing you do
that you still really need to.

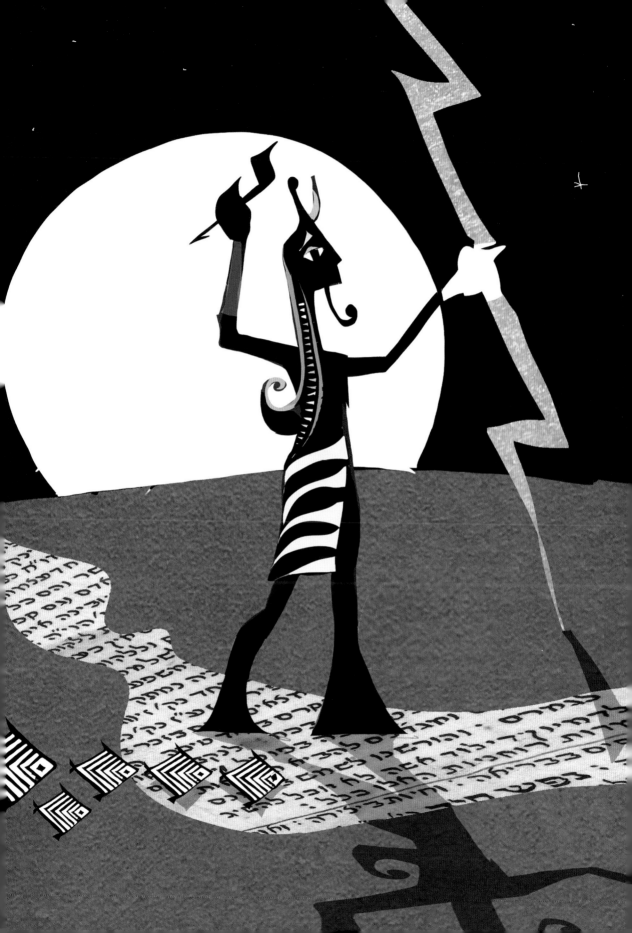

Anat, Ashtoret, Ishtar, Esther,
Astarte, lower letter ה
The number five, *hamsa*
Hand of Miram and Fatima—

You are all my mother's amulets
and all my mother's charms
leaving me protected
from abandonment
and harm.

I hear the faraway clap of a rhythm
and the shout of olé—
for the bull, the calf,
the old gods,

י

ו

and ה.

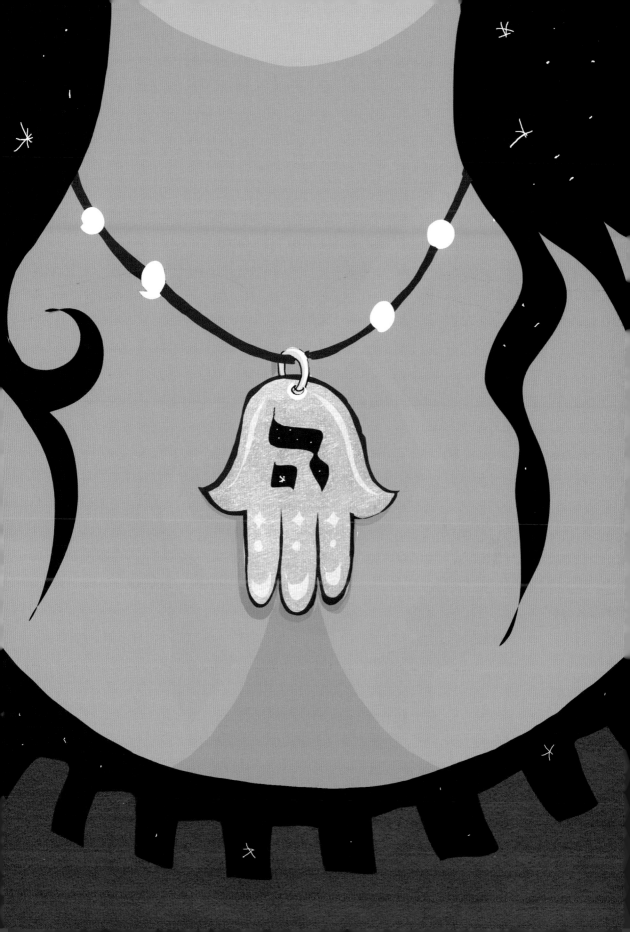

No longer gods now, but God,
four threads interwoven,
four letters, four forces
the Greek now endorses—
Tetragrammaton
for our Hebrew sources.

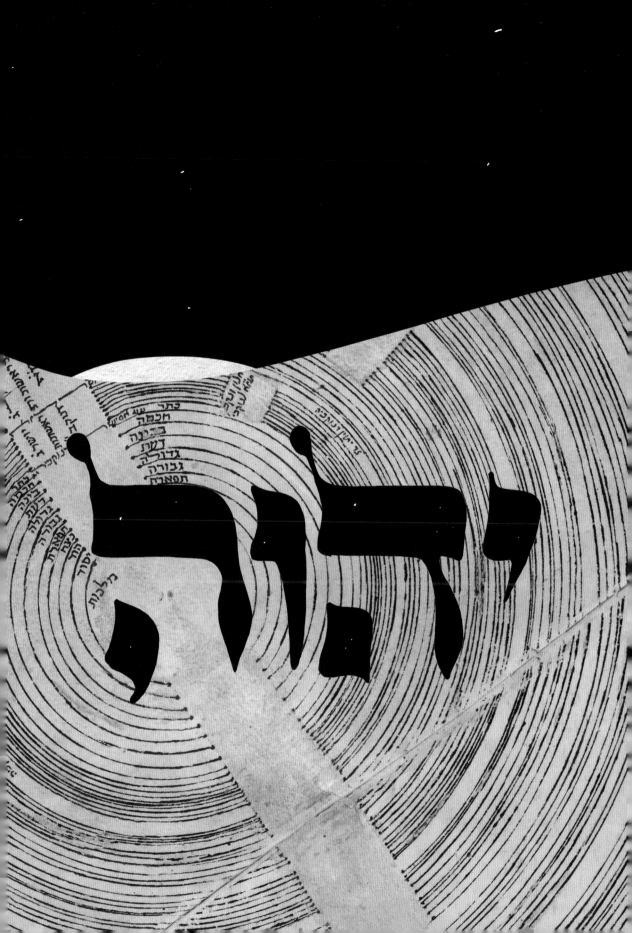

Mother letters,
of water, fire, and air—

מ made—י
and ש made—ה
א made—ו
then together they
formed alchemical earth
from a—ה
made of clay.

Then they all held hands
and they floated away.

Time, Time, Time, Time

what was—היה

what is—הוה

what shall be mine—יהיה

and woven into stories told,
what could be—והיה
imagined or foretold.

You are the verbs of creation,
in four-part harmony—
or if not harmony,
then syncopation.

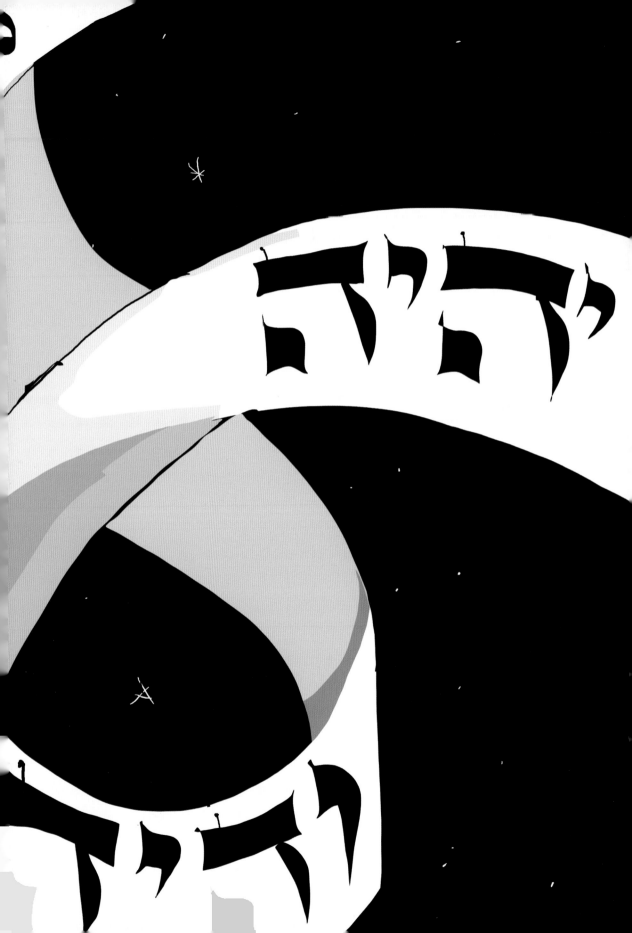

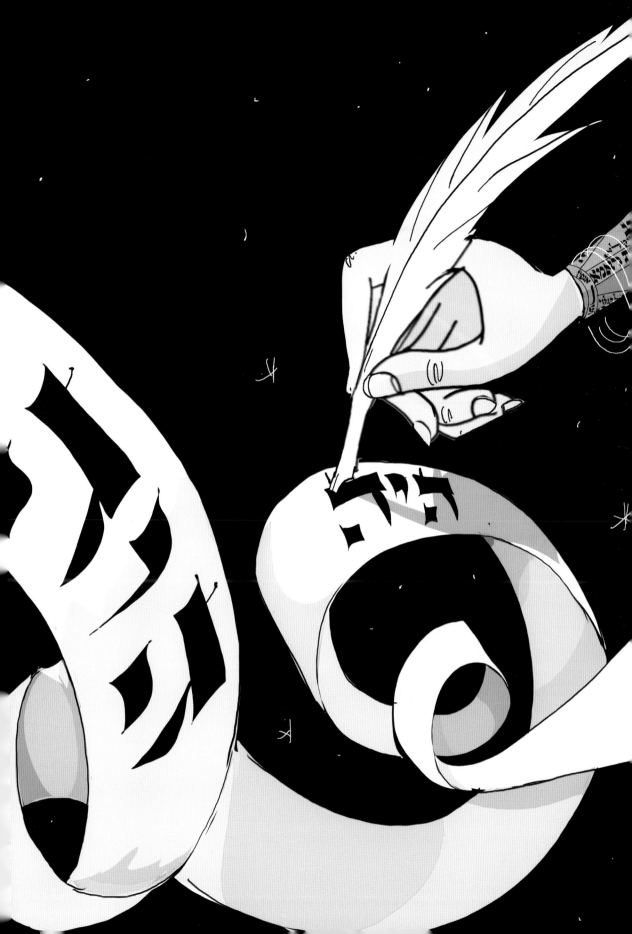

You four,
you rise, you stand—
past, present, and future as one.

And so do I.

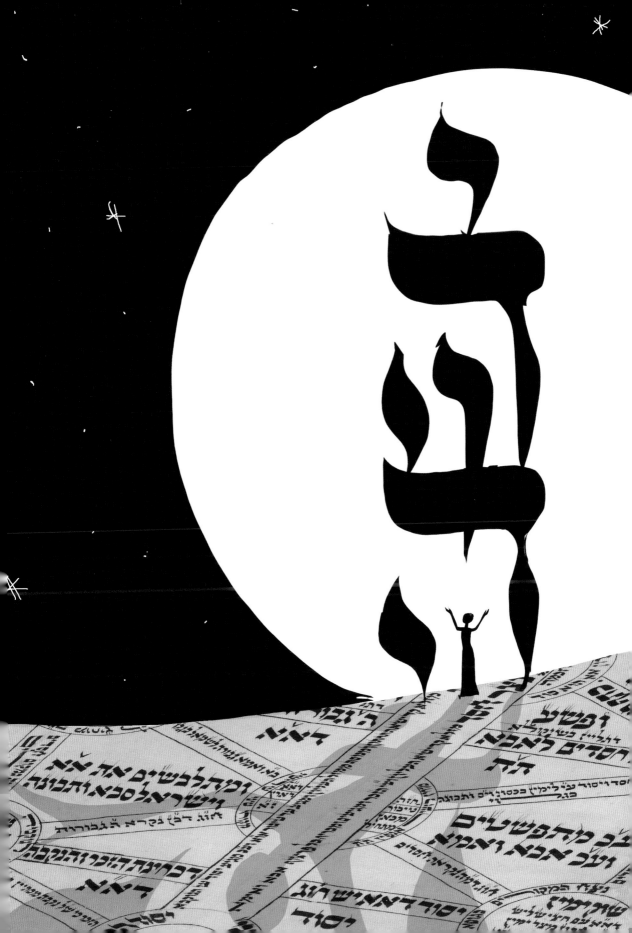

And a doorway opens.

And some, like me,
without thinking—
they walk through.

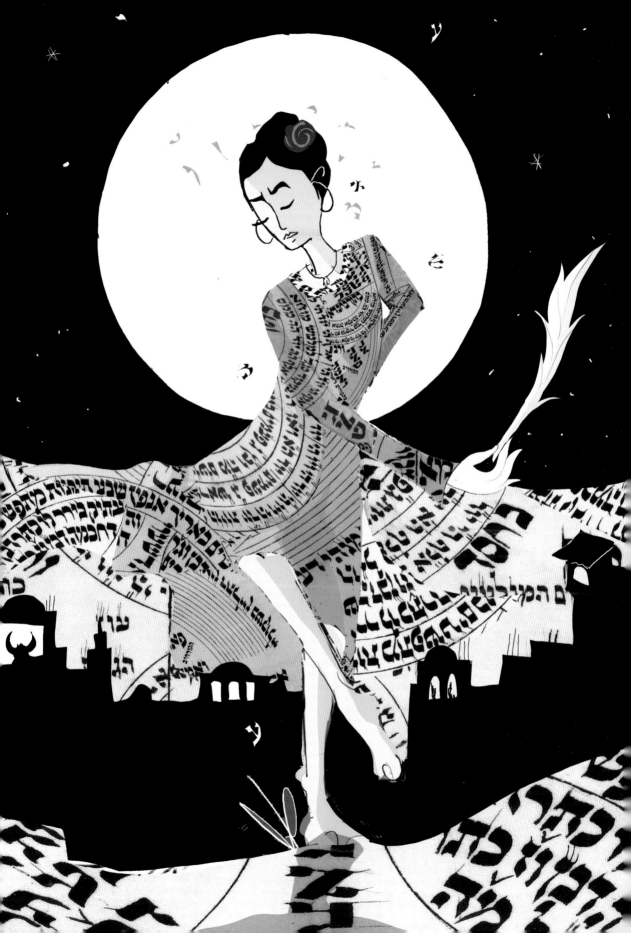

And some,
like me, are gone.

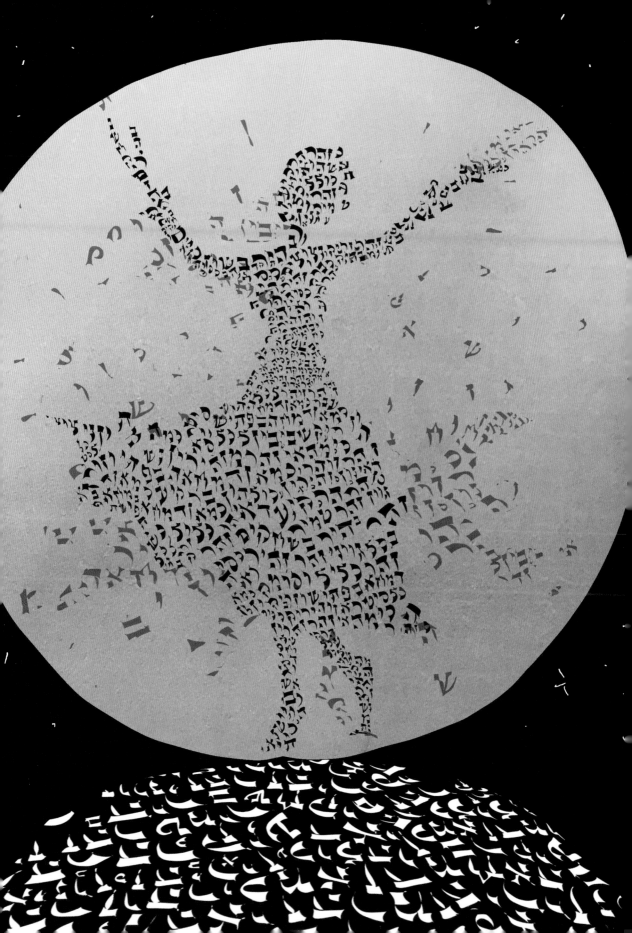

I think it was
always what I
was best at,
running away
into the solitude
of letters.

Was this the goal,
what I was
raised to do?

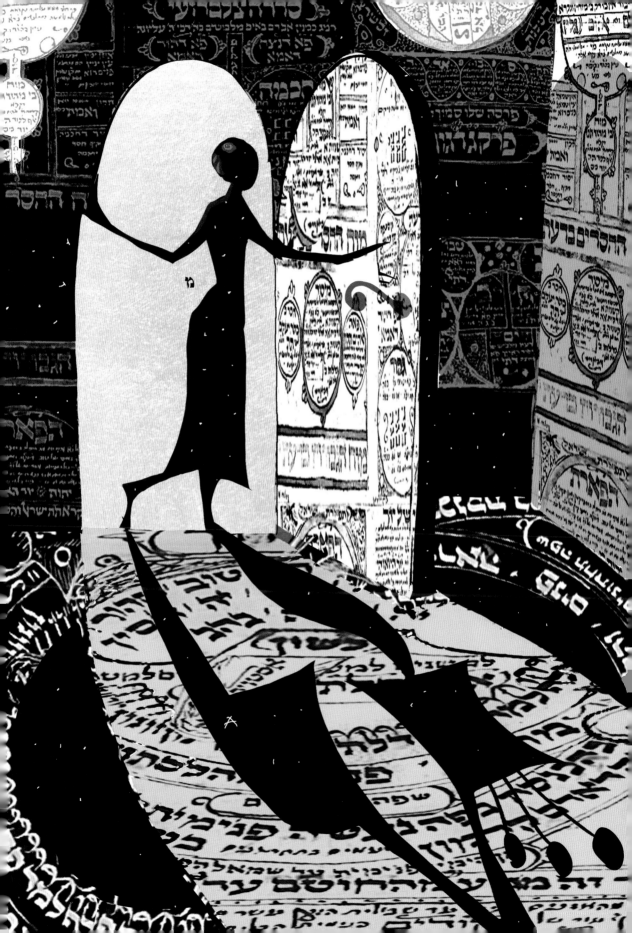

I can stay like this,
communing with letters
for a long, long time,
until I feel the earth quivering below
and a sharp breeze tapping me on the shoulder,
as if I had forgotten the world.

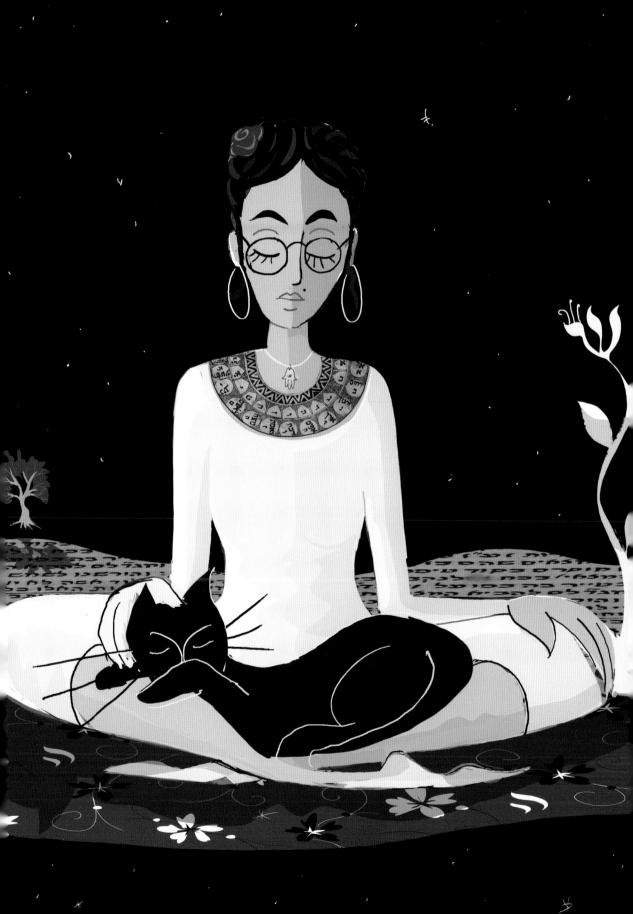

"In the very beginning,"
my father once said,
"came the first Mother Letter, ש,
made of fiery thread."

But I learned something
my father did not know—
In the beginning, ש was a boat
that a goddess rowed.

She whispered to me this alternate view:

"ש was not yet a letter,
and I was no god's wife—
I descended alone to bring the Tree of Life."

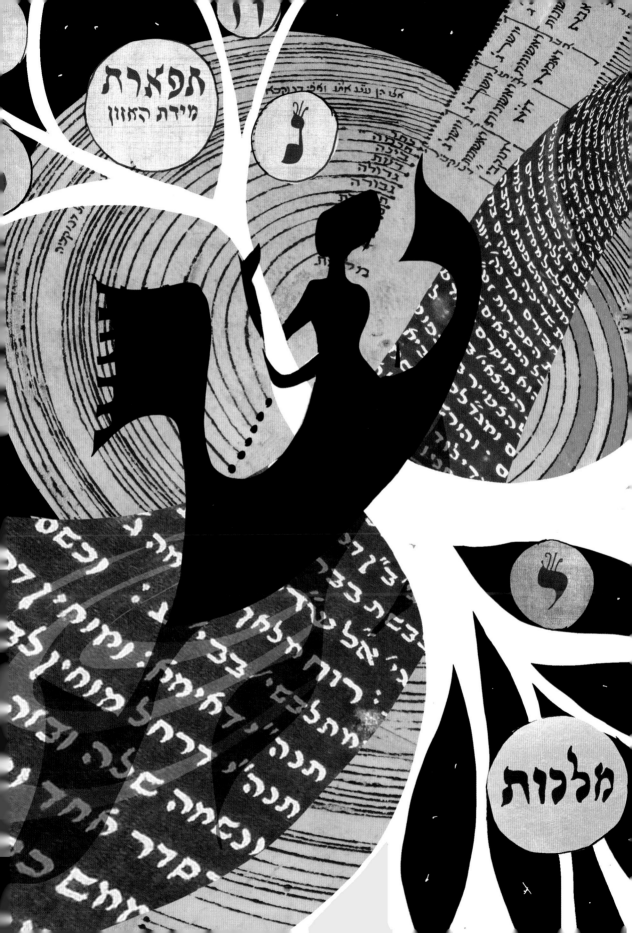

Second Mother, מ,
of primordial waters—
incubating, gestating,
lulling nascent life within.

You make me ache
to give birth too—
every way I can.

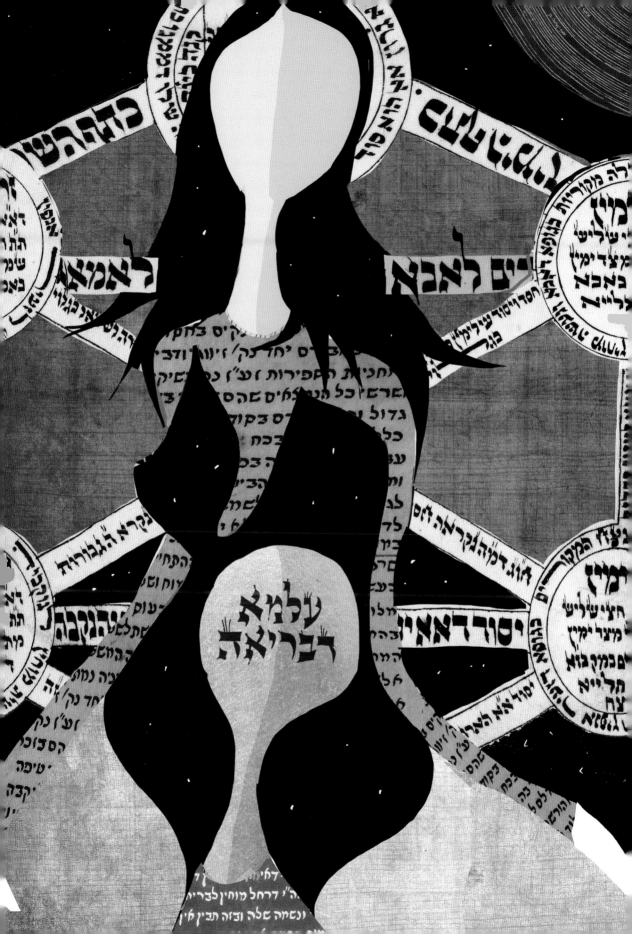

Last Mother, א, the ethereal one—
lands lightly on our arid sands.

And when the dervish winds begin to gust
she spins and scribbles in our dust.

She inscribes what she sees,
she told me in trust,
"Not that it's my job, but because I must."

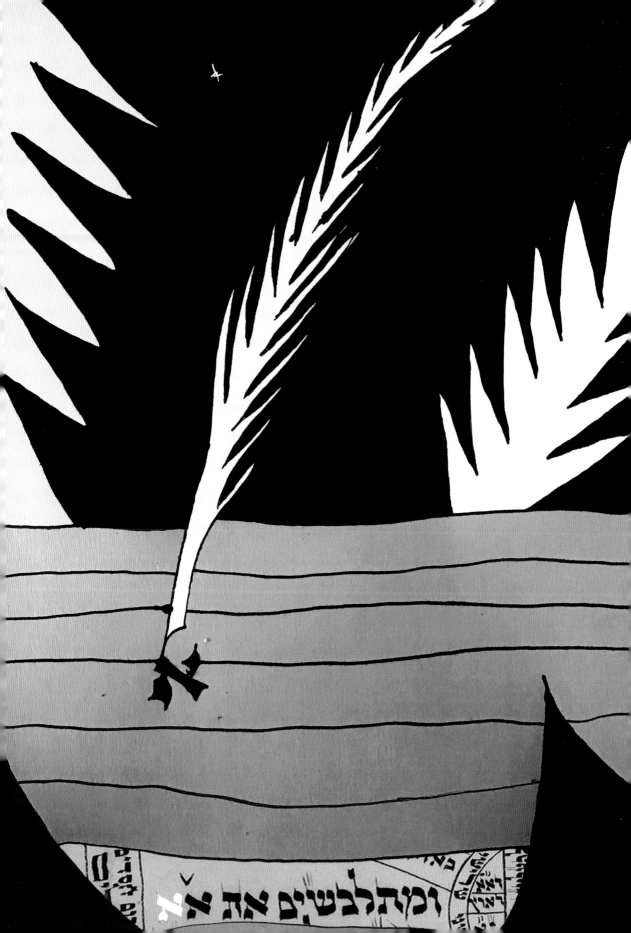

Was it easier before
we had writing, quills,
and grammar?

When we could be comforted
by gods, goddesses,
and bulls?

Now we have
Mothers, Doubles,
and Elementals,
answers more than questions,
written laws,
and rules.

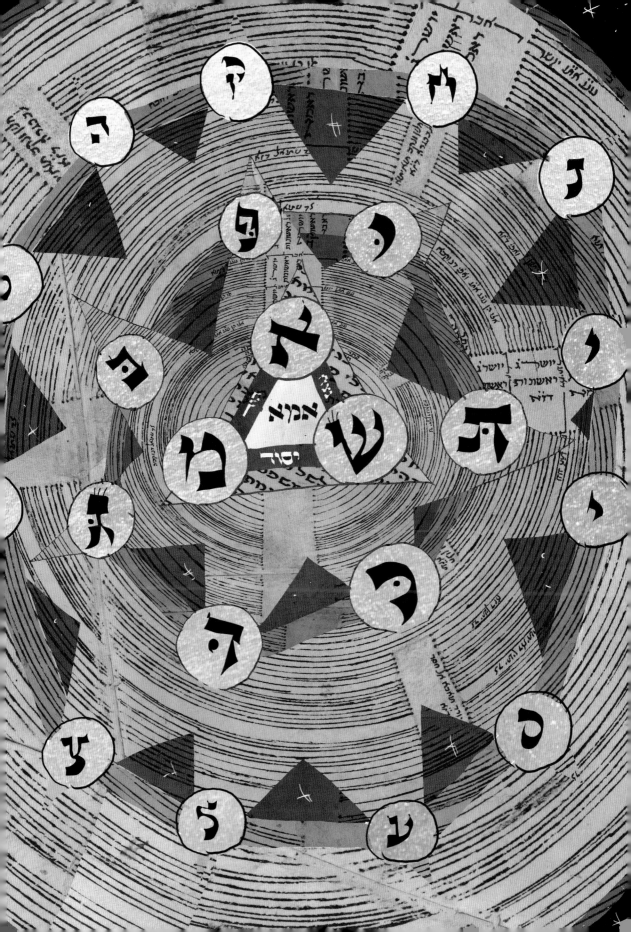

Of all the Double letters,
I trust most in בּ,
to keep me safe in city
and in courtyard.

For בּ, it was who started it all,
from *Bireishit*
to *Zohar*.

But גג, too,
can comfort me
with acts of human kindness.

And when
the desert winds blow hard,
she says she doesn't
mind much.

דﬥ invites me to be brave,
offering mystery and thrill—
but doors that seem wide open
can sometimes slam as well.

You lock us in,
you lock us out,
I've lost the key,
I've lost my way—

Then through the mist far away—
I see a *mezuzah* on display.

And a door opens—

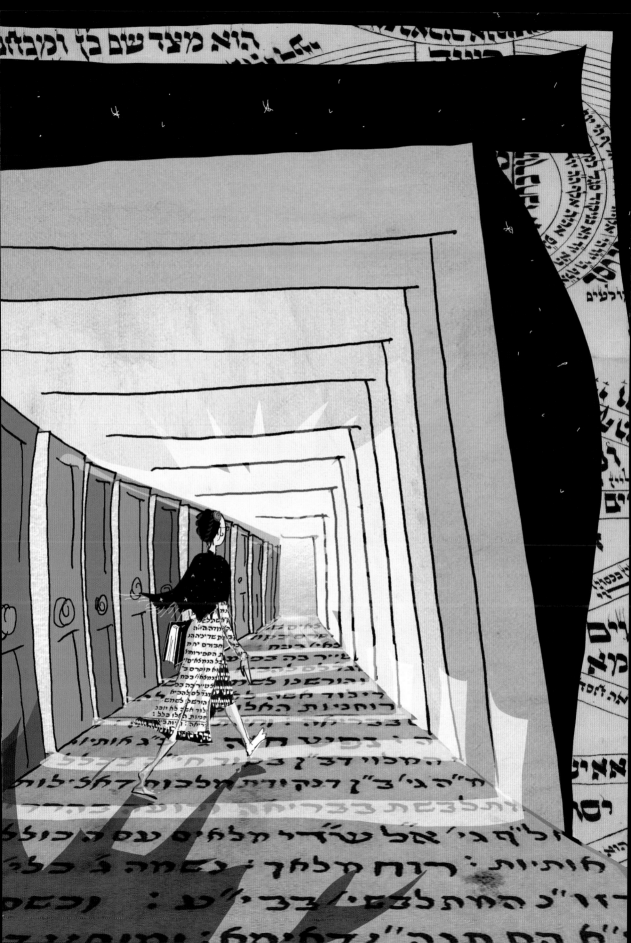

Then כב whispers a tale
of a shining gold crown
that lives in the
Garden of Paradise.

And its light filters down
over mountains and towns
and shines on all
creatures of the
universe.

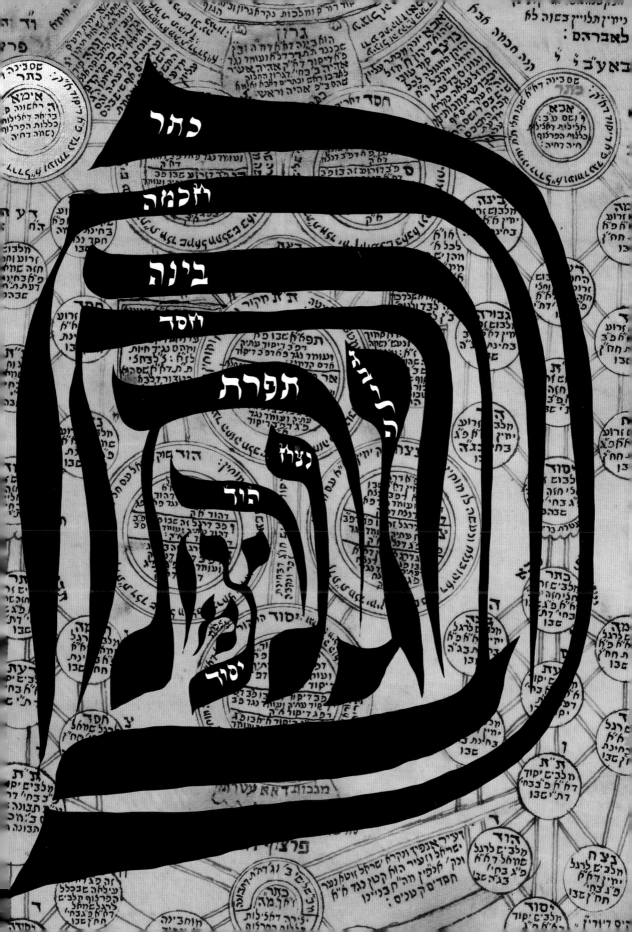

פפ warns me, be careful
of what you do and say.

Every breath,
both in and out,
please watch out.

Hold close that letter י
that's in your mouth, dear,
let it steep inside
your thoughts
before you speak.

Remember, we hold secrets
of our own, dear.

They're not secret anymore
if you should speak.

Double Letters
they are two-faced,
and some are trouble.

And of all
the troubled ones,
watch out for רר.

In their heart they may be
noble, wise, or learned,
but sometimes when they speak,
it's only snakes.

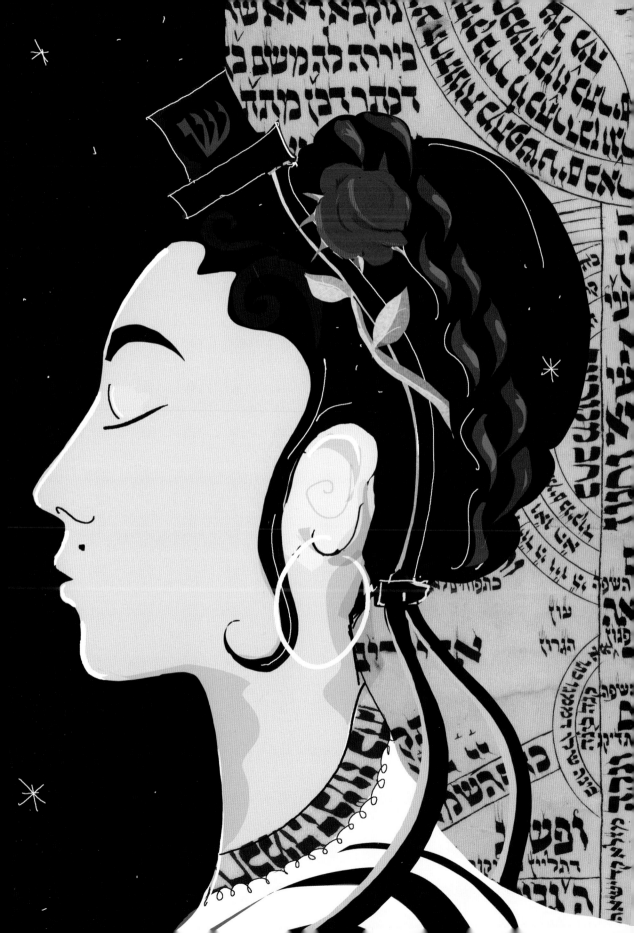

"Shhh," I told the letters, "settle down,
so תת can teach us Torah."

Suddenly, no one was around
but a heavenly sound.

Besides, תת doesn't only
teach out loud.

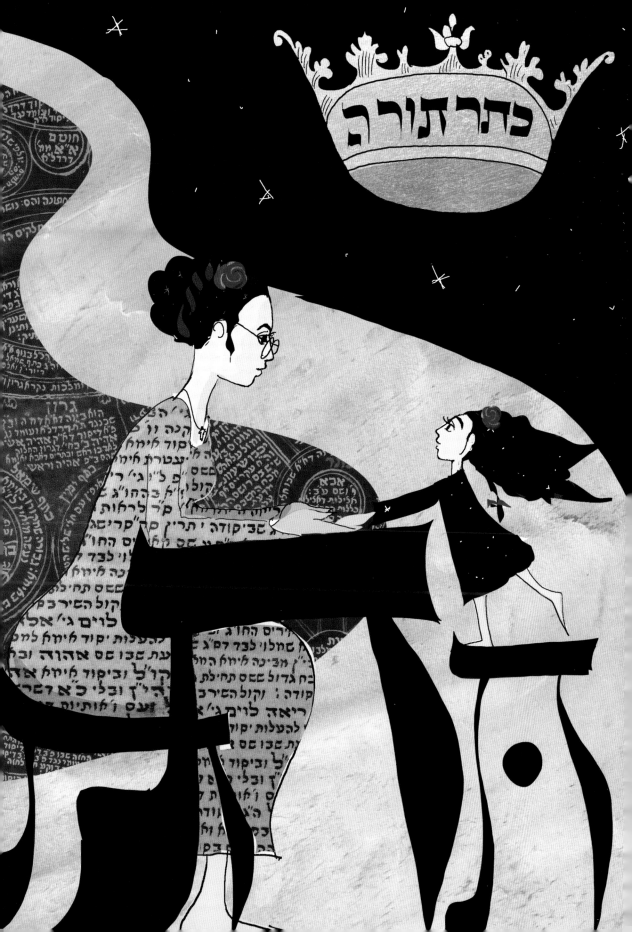

Then twelve Elementals
banged loudly
at the gate,
demanding their
own hearing.

"We've stories too," they cried,
"we form the tribes,
we name the months,
and springs, and wells
where השם dwells."

And
so I jotted
each one down
and with a kiss,
gave some a crown.

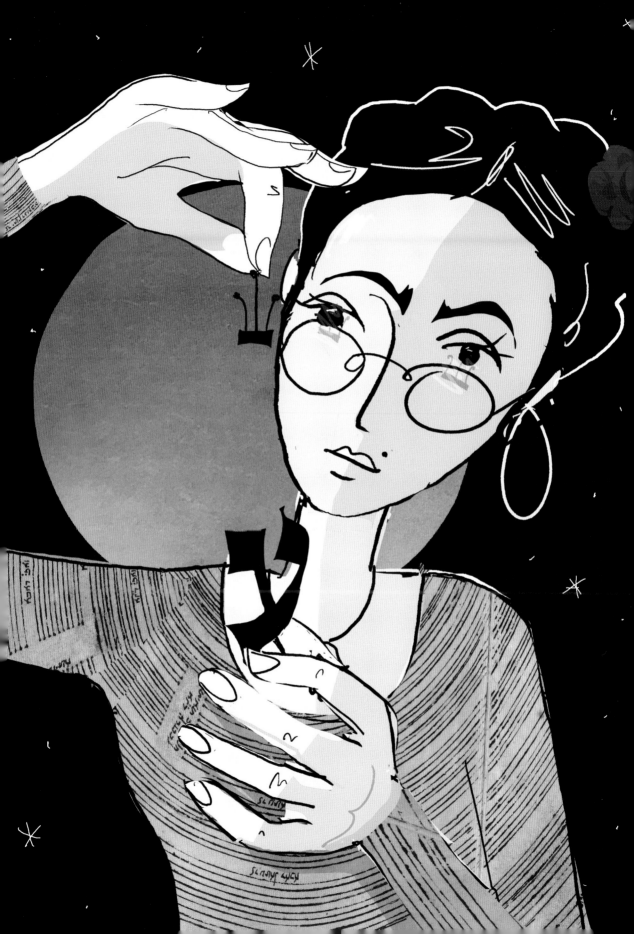

There's
ה above
and ה below,
ה at the start,
and ה at the end. . . .

ה above is for the Mother
and ה below for
Shekhinah, the bride.

ה at the start makes
things important
and at the end
makes things alive.

Oh, the never-ending ו-ness of it all.

I speak of turbulence and chaos,
emotions and embraces,
rejections and acceptance,
and a multitude
of choices.

And the story does not end there—
And And And And—
there's more to ו than I can stand.

ו serves as male and stands up straight,
he holds my hand and fuels debate.

And sometimes, when things get slow
he'll bring me dreams to help me know.

When I am old,
I'll use a ʔ
walking stick
with sword inside.

My tongue will be sharp,
but I will be kind
and thoughtful
and wise at
my demise.

A suffering
consolation prize.

סבוג
רק בטרם
ע"ה לגלי מת הכ
ת בסוד מ"ה יקר
ודה : ותחו
חסד עליון הוא ס התפסטו
שרם לאימא מתלבש בתוך
הגעלס ר"ו"ד דאבא הנעשה
לזרועות א"א שם מתלבש ונעלס
כ"ד לאחורי ה דתכונה : תיקון
מות בשרשי הזקן ונק תשר לך
רות הקטנות התחגרין תתן
יירין תלויין בשוה וה לא
לאברהם :

לאברהם

באע"ב ל

חסד דחריך חנפי ימין

גבורה ד

אבא
נ ושם ע"ב
חכילות דאילות
בלבות הפרלוף
חיה רחיה

פ"ח דזרוע
ג שאל דלחאבן
פ"ח דל"ח דעצב
ועוד עגב פ"ח דפצדנלב
דה ה

ס פ"ח דזרוע זה כולף
דף פ"ח דקנת לעתיק
נגד פ"ב ד דף דבנלה לא
כמנת ועומד נגד
פ"ב דל"ח דן ה
א פ"ח

בינה
מלבוש זרוע
ידין א"ח פ"ח

I seek you, ח,
your wisdom and
your righteousness.

Like my father before me,
I've sought you my whole life.

I yearn for you, ח,
for חכמה and for חסד,
but they say without a חתונה
you can't live a good life.

I dread you ח,
so hard to live up to.

Can't we
just celebrate חיים
for our souls to reunite?

גבורה רח"א

חסד רח"א

כתר רח"א

אמא

אבא

חכמה

בינה

דעת

חסד

גבורה

ת"ת

הוד

נצח

יסוד

ת"ת מקור

נצח חיה

When I blink,
ט is ancient
and is earthen.

Carrying
water or wine,
lentils, couscous,
or cracked wheat—
olives or merguez
or other tasty treats.

ט is the container
for all things
that are good.

That makes her the ruler over
shouldn't and should.

כלהים : בלים רח"ם" ס וכ : עין ימין הוא
דראו"א נחא"ובניות הור דראו"א הוא כג"י"ע נהורין
"א אלהים דיורי"ן אבל תהין ח" רז"א :
חב"א דז"א שבס טס" מ עתיקא ל"יורי" זרו
נח ואלי"רה ברית דלב : אד רוח"ן רק"ג דא"ימא זא"ח

א" יר רג'י' כבד' גליור יו'ר ג' חזה :
ה מ' דתבונה שמתחנה לאה ע"ה ג' ל"ז דהלוי ק"ג דתבונה ולאה כה
שם חדריס שבעטרת יסודה ושם טבעות דקנה הוא מלוי לבד רם"
וו' טבעות הס ו"ק שלה המתפשטיס לו כנפי ריאה

"י ג' ריאה היא מ"ימא הזהירה לעינים
לרחות ג'י' כ"ף ע"ג ע"י נא ולבא

O little ׳,
so deceptively small,
you who seek
to create brand new life.

You are the hand
of the patriarch's right,
the stand-in for God,
and the spark that ignites.

ל is the lightning bolt
of knowledge from above,
and the fountain that transmits it
from below.

It courses through the worlds
and travels mind to mind—
and if we nurture, plant, and water it,
we hope that it will grow.

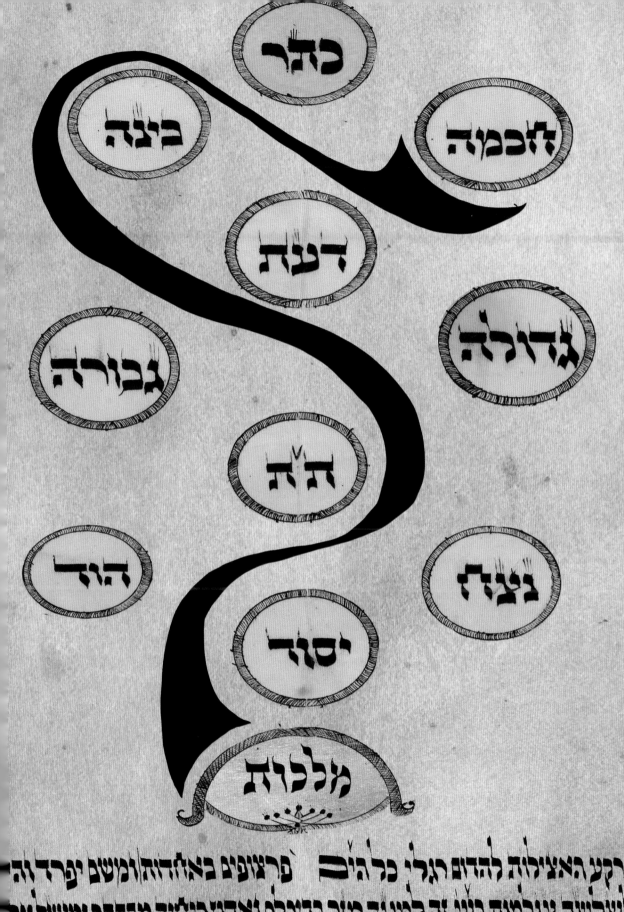

כתר

חכמה

בינה

דעת

גדולה

גבורה

ת"ת

הוד

נצח

יסוד

מלכות

קרקע האצילות להדום רגלי כלהי"ם פרצופים באחדות ומשב יפרד זה
שרשה עולמות בוע זה למטה מזה בהם מה זה וארזה יחיד מסהר ומושל על

נ is for נחש,
for snake
(and for women).

For Inanna,
the goddess turned
into a villain.

But wait—
נ is for נשמה,
the highest level of soul,
and for נפש יהודי
given the Torah scroll.

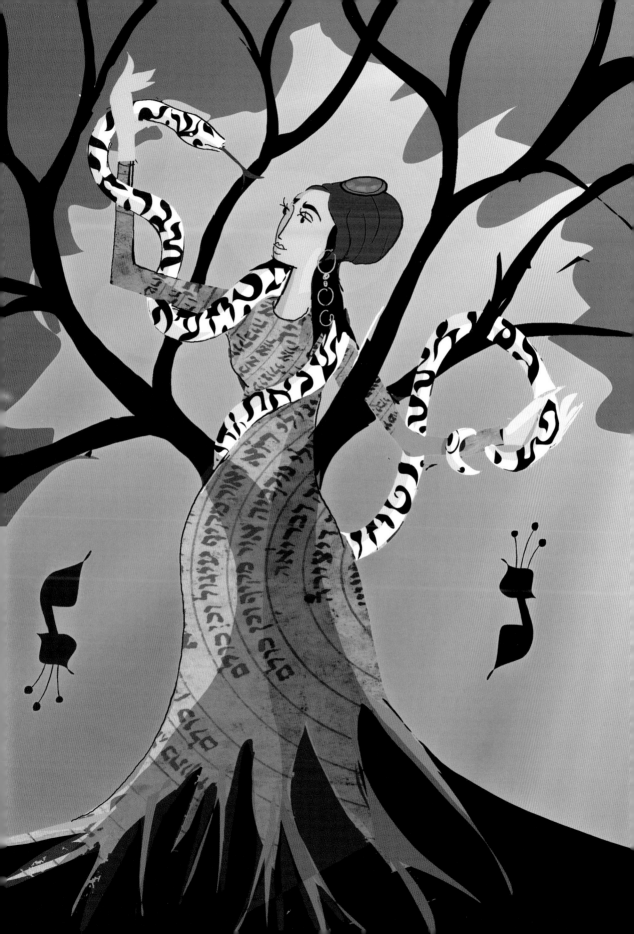

ט—you are secret,
occult, and self-contained.

ט—you are hidden,
in the Tree that is forbidden,
where our dreams all have been written
with the letters we've been given,
whether sacred or profane.

אור מקיף

עיגול

א is a glottal stop,
and ע a pharyngeal fricative.

I learned this studying Arabic,
for which I am appreciative.

And should I care
where a letter sits within my throat?

I should, for meaning changes
not only when I read out loud
but in the amulet
I just wrote.

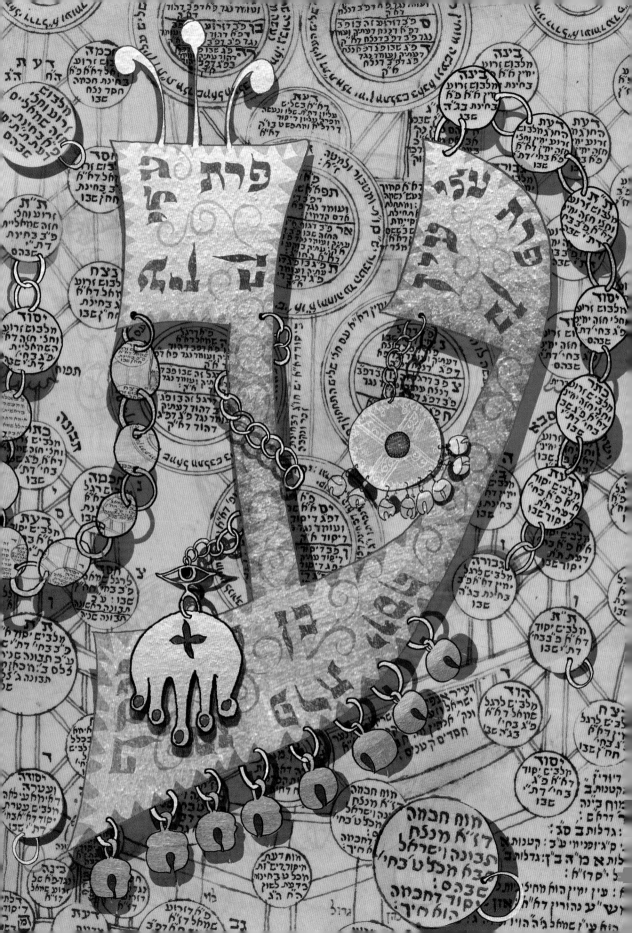

O Abba—how I miss you!
O Imma—you as well!

I made a terrible mistake
not returning home
to say farewell.

Someday,
out of צ and ץ
I will build in your honor
a communal retreat—
with garden and fountain,
and tree to be complete.

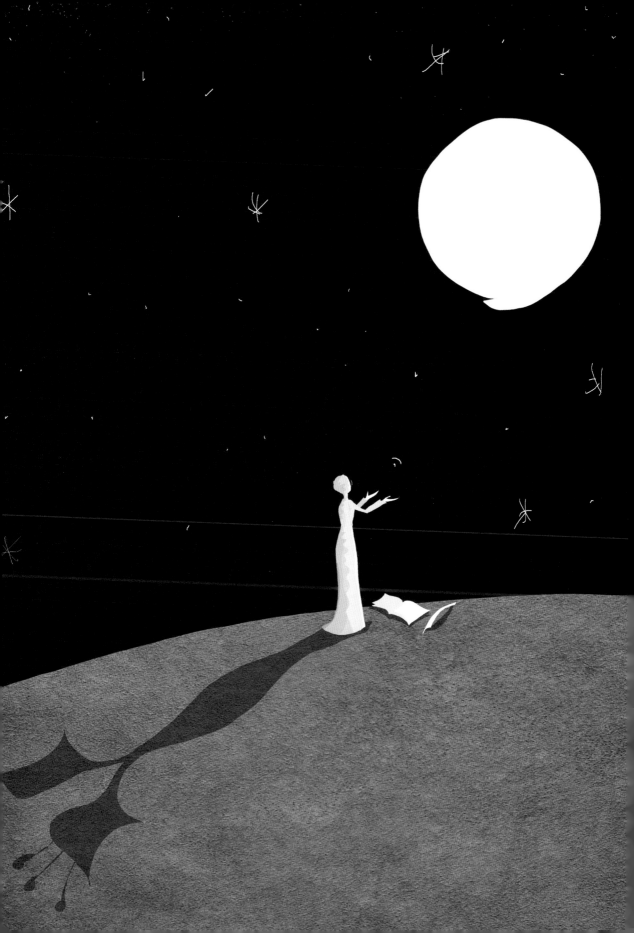

It's you, letter ק,
who can mark a thing קדוש.
In your presence קום, we rise,
and קול out when we recite.

But sometimes even
my own learned father
would just קוף or קיצל around.

And when
my letters
all were done,
I inscribed that
promised garden.

And then I dipped my quill again
and begged my parents' pardon.

I drew them letters as a gift,
but they lifted off the page.

They all took flight and they were gone
to mark a path to travel on
that was worthy
of a sage.

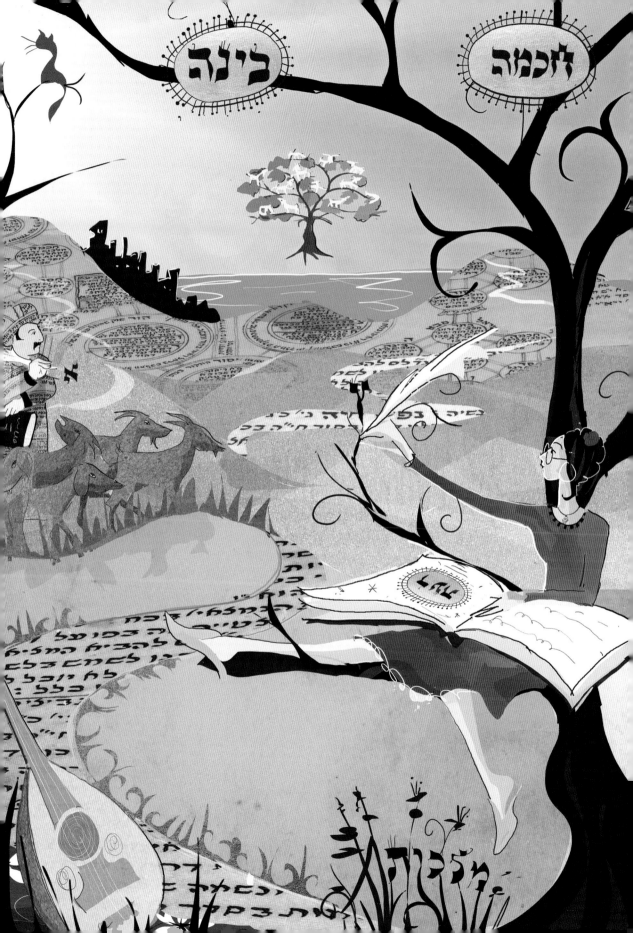

I dreamed I gave
my long-lost Abba
crumbling books to read.

I dreamed I saw
my inquisitive son
sitting at Abba's knee.

"Such a blessing . . ."
I heard my father say,
the way he used to say to me.

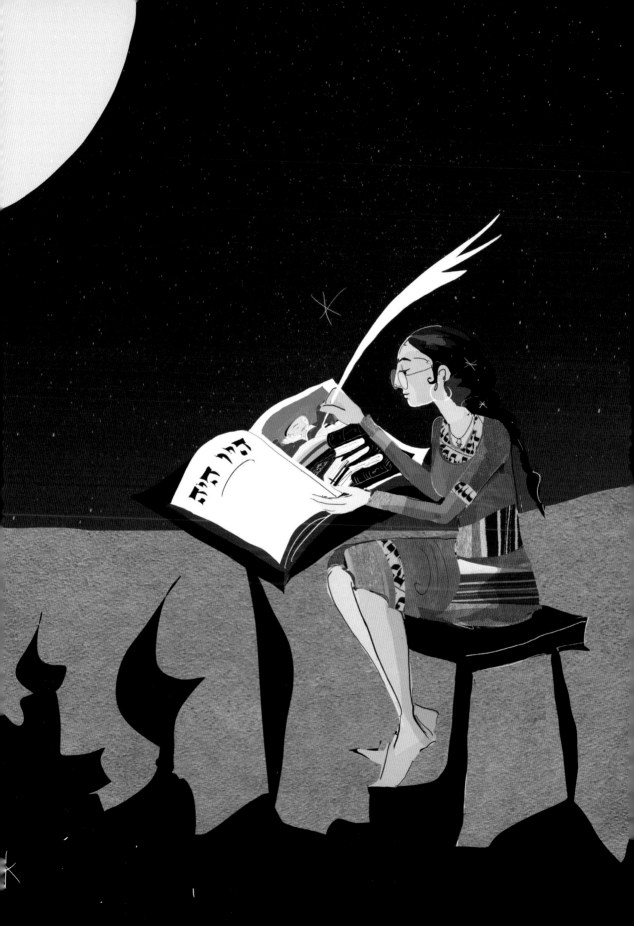

I dreamed
I had a mother,
she was handing me a tray.

She said,
"Give those
menfolk Turkish coffee
before you send them all away."

And because it was a dream,
I dared not disobey.

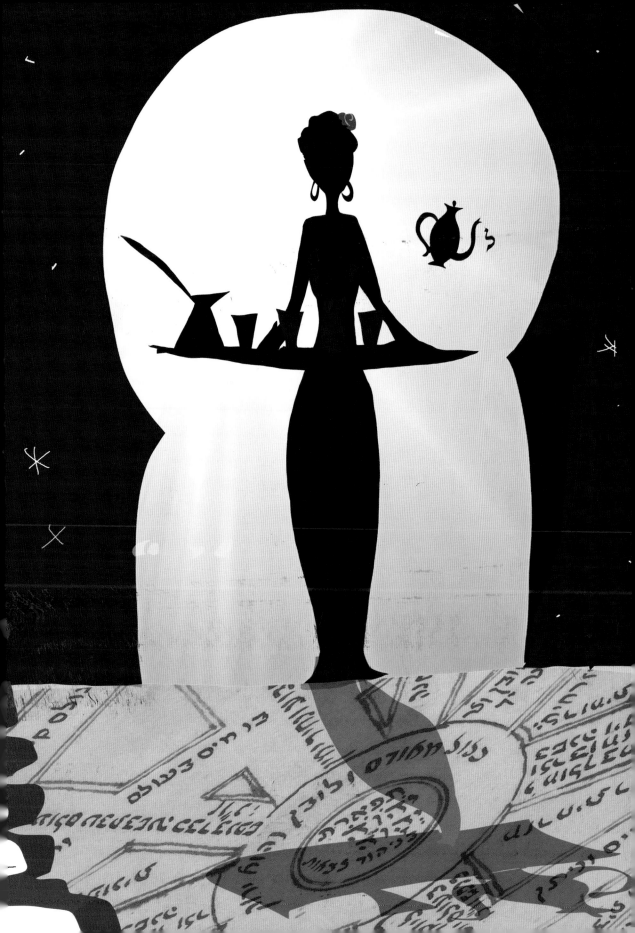

I dreamed myself
a little girl
whose eyes took in
the written world.

I taught her
everything I know
about what was and wasn't so,
about the sages in *Pardes,*
about the stars in outer space.

About the crumbling books my father loved,
about below and up above.

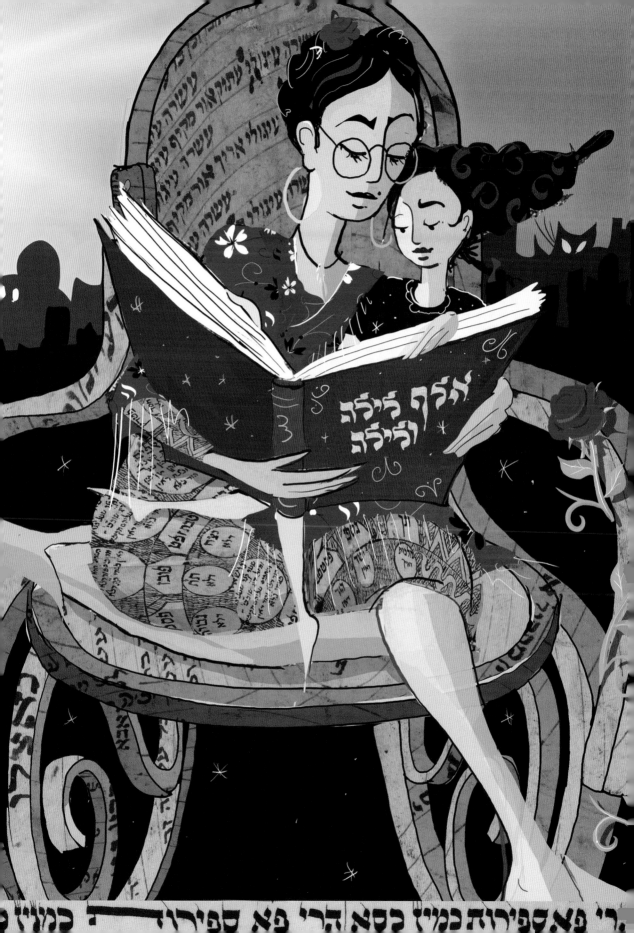

I called my daughter Anat,
and my firstborn son, Adam.

"You told us ancient tales,"
they said, "about where
we all come from."

"But Mama,"
they said to me—
"*our* story's just begun."

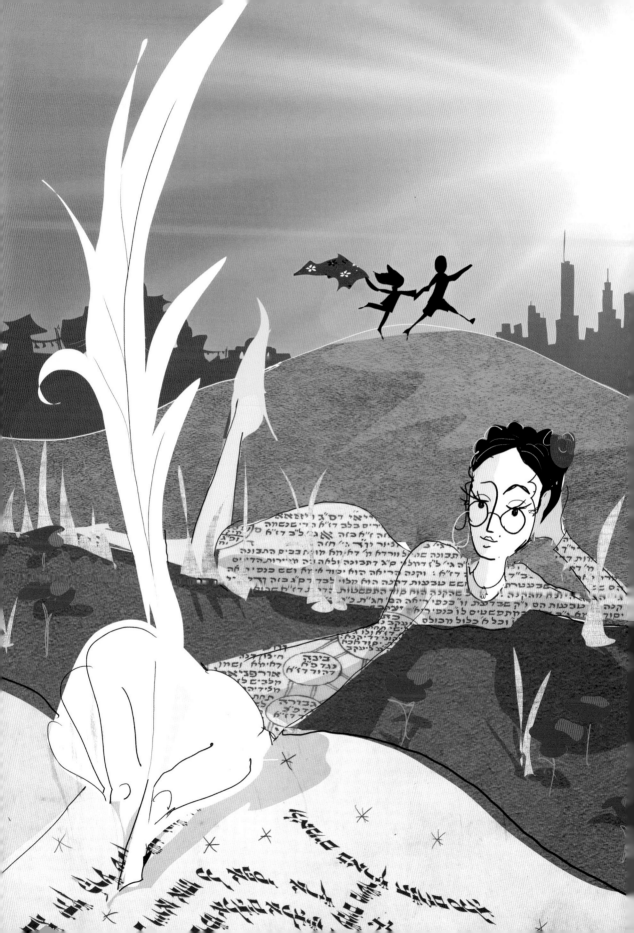

EPILOGUE

It's the day before creation.
I open my unborn eyes and yawn.

There is only light,
light inside this darkness.

I stretch and give a little kick.

Nestled within my mother
I am warm and safe
and whole.

Nothing, nothing is broken.

This, surely is בראשית ברא—*Bireishit bara*—
this is how my life begins . . .

This time round I'll ask my mother
all my questions on the Torah—
first Hagar, Avraham, and Sarah,
Ishmael, and *keinahora*
Akedah and *Lech lecha*.
What does it mean
when we say
the *sh'ma*?

But first—a door opens.

Come and see—

AFTERWORD

The character of Malkah started out as just a name. But, slowly she began to develop a personality of her own, sometimes unpredictable, with opinions and a will, desires, and a direction of her own. Occasionally, Mira and I would take months to discover what it was that she wanted. She is still a mystery to me.

Once Malkah was conceived, like all the best characters she began to grow right before our eyes. She evolved from a young girl into a woman capable of having her own child. When I first started to draw her, I'd start with a very simple black dress: a silhouette, like a Hebrew letter—a cipher—in which even the beauty spot on her top lip became a vowel, a cholem on top of the letter Vav. In Hebrew, the vowel "cholem" alludes to the word "chalom," meaning "dream." Malkah is a dreamer, a decoder, and an avatar of letters. And, at the zenith of her adventure, she can no longer contain them, and she explodes into a million new letters, each one a new adventure.

Malkah learns to travel inside and outside of text, internalizing and manifesting the things that she has read: a flaneur in Paris, an anthropologist in Tunisia, a Sufi in Turkey, a *flamenca* in Spain, a goddess in Mesopotamia. Her accomplice is a cat of mercurial ink—a kindred spirit in her quest for meaning. Together they sit on the shores of ink, watching the moonlight flicker on the Black Sea as it says in *Bireishit,* "the spirit of Elohim fluttered on the surface of the deep."

Malkah's Notebook is also the story of the exile of the Shekhinah. At first, she is locked away, hidden inside a patriarchal library— "the girl at the window," exiled from her mother, from herself, and from the world. But she has the courage to break free and rediscover the Torah, and the world, on her own terms.

I am grateful to Mira for having invented Malkah, who is, above all things, a reader like you.

—*JB, Bristol 2022*

ACKNOWLEDGMENTS

Around the year 2000, my daughter asked me to write down the stories of my life, and so I opened a new notebook and began. But my voice began to change and Malkah emerged—and my stories shifted and became hers. In 2013, when the imperative to tell her story became palpable, artist Josh Baum appeared, along with his animator brother Sam, to present her life in a film, *The Day before Creation*. Renowned Hebrew calligrapher Izzy Pludwinsky had recommended Josh, and my daughter, the movie's artistic director, agreed. But the movie we produced told nothing of what was inside Malkah's mysterious notebook.

The ideas in this book come from my earliest teachers, later professors, senseis, colleagues, students, and women of North Africa, as well as archaeological sites, Jewish mystical texts, and the libraries of the world. They all have influenced my experience of the animistic, mystical, and physical worlds in which the Aleph-Bet resides. For specific sources, see *Part V: Crumbling Old Books in the Dusty Old Library*, online at thedaybeforecreation. com and academia.edu.

My father, Seymour Fromer, gave me my first Aleph-Bet storybook and nurtured my love of the ancient Near East, the Islamic world, the contemporary Middle East, and North Africa, It was he who showed me our ancestral ties to other peoples in those lands and taught me that we are part of that mosaic. *A part of.* Both his teachings and those of my mother, Rebecca

Camhi Fromer, laid the foundation of my understanding and the stimulus for my own exploration of the world.

My colleague Fayeq Oweis graciously allowed us to use his Arabic calligraphy, and William L. Gross let us use his magnificent collection of ancient amulets in our illustrations. My student, archaeologist Tim King, and his partner, Alessandra Andrisani, helped us research and depict the ancient gods. Natalie Reid heroically edited all versions of this book. Birrell Walsh, Erin Vang, and Tim Lavalli also read and offered insights—my apologies to all for roads not taken.

The intuitive James Leventhal introduced me to Angela Engel and ultimately to the Collective Book Studio. Thank you, Angela, for your dedication to collaborative publishing and to your team, for easing me out of the Ivory Tower. Thanks to Elizabeth Gonzales James, Dean Burrell, and especially Amy Treadwell for smoothing the path.

Malkah's Notebook is written with gratitude for my kids, Michael and Rayna, for their kids, and especially for you and yours. To open doors, close your eyes and turn a page. Open your eyes and enter. Come and see where the Hebrew letters can lead.

—*MZA, San Francisco 2022*

ABOUT THE AUTHOR

Mira Z Amiras was raised on her mother's accounts of the Inquisition and Holocaust, and her father's tales of the Hebrew Aleph-Bet letters and their role in the creation of the universe. She is Professor Emerita of Comparative Religion and Middle East Studies at San Jose State University. Mira received her PhD in anthropology from the University of California, Berkeley. She is author of *Development and Disenchantment in Rural Tunisia*, and writer and director of the award-winning animated movie *The Day before Creation*. She lives in San Francisco with her family.

ABOUT THE ILLUSTRATOR

Josh Baum was born in London and grew up in Bristol, England. He studied painting at the Massana School in Barcelona, Spain, then moved to Sfat to study in a Hasidic yeshivah, where he trained as a Hebrew scribe. After writing a Torah scroll in Jerusalem, Josh attained an MA in fine art from Central Saint Martins school in London, for which he was awarded the Future Map prize. In his work as both an artist and scribe, he explores the Hebrew letters as sacred signs as well as objects of profound beauty. Josh is a published author and illustrator, and currently lives in Mitzpe Ramon, Israel, where he is director of the art school.

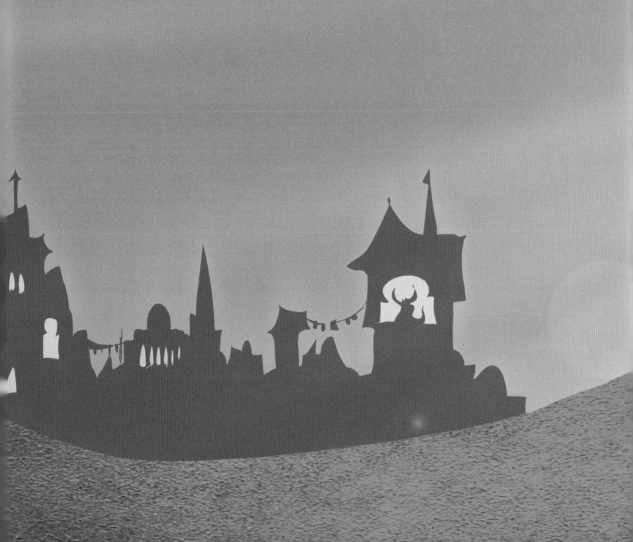